The DK Art School

AN INTRODUCTION TO
PERSPECTIVE

The DK Art School

AN INTRODUCTION TO
PERSPECTIVE

RAY SMITH

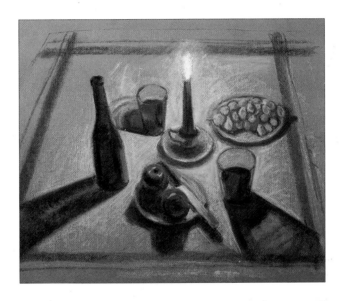

DORLING KINDERSLEY
London • New York • Sydney • Moscow
www.dk.com

IN ASSOCIATION WITH THE ROYAL ACADEMY OF ARTS

A DORLING KINDERSLEY BOOK
www.dk.com

Editor Peter Jones
Art editor Spencer Holbrook
Assistant editor Neil Lockley
Assistant designer Stephen Croucher
Senior editor Gwen Edmonds
Senior art editor Claire Legemah
Managing editor Sean Moore
Managing art editor Toni Kay
DTP designer Zirrinia Austin
Production controller Meryl Silbert
Picture researcher Jo Walton
Photography Tim Ridley, Andy Crawford

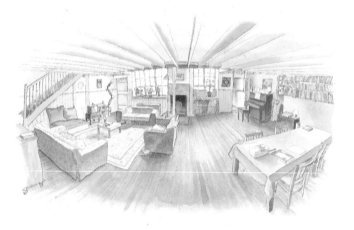

Note: Diagram annotation in bold text refers to complete lines, plain text refers to points (with particular reference to pp. 20-21, 22-23, 30-31, 34-35, 36-37, 38-39).

This DK Art School /Art book
first published in Great Britain in 1995
by Dorling Kindersley Limited,
9 Henrietta Street, London WC2E 8PS
2 4 6 8 10 9 7 5 3 1

Copyright © 1995

Dorling Kindersley Limited, London

ISBN 0 7513 0750 5

Colour reproduction by Colourscan in Singapore

Printed and bound by Toppan in China

750. 18/0123765 6

CONTENTS

Introduction	6
A Brief History	8
Starting Out	12
The Picture Plane	14
Horizon or Eye-Level	16
Three Views on Perspective	18
One-Point Perspective	20
Curves & Circles	22
Atmospheric Perspective	24
Detail & Definition	26
Gallery of Atmospheric Perspective	28
Two-Point Perspective	30
Two-Point Painting	32
Box Grid Construction	34
Inclined Planes	36
Plans & Elevations	38
Three-Point Perspective	40
Three-Point Painting	42
Gallery of Landscape & Architecture	46
Reflections	48
Sunlight & Shadows	50
Artificial Light	52
Gallery of Reflections & Shadows	54
Modern Devices	56
Gallery of Perspective Devices	58
Anamorphosis	60
Curvilinear Perspective	62
Gallery of Curvilinear Perspective	64
Curvilinear Composition	66
Gallery of Alternative Approaches	68
Glossary	70
Index & Acknowledgements	72

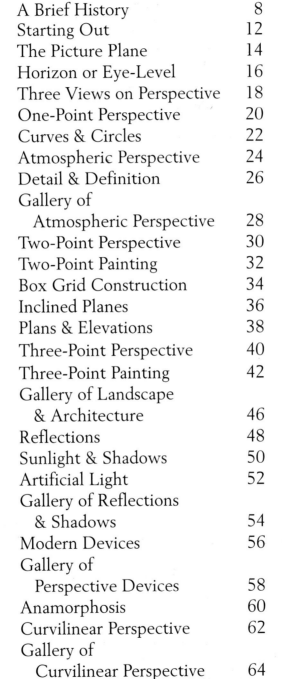

INTRODUCTION

IN ITS MANY DIVERSE FORMS, perspective provides us with a means of arriving at a convincing two-dimensional visual picture of the complex three-dimensional world we perceive and inhabit. The idea of perspective is attractive to us because it is a system that allows us to enclose and contain the world, creating a two-dimensional scale model of reality. In this way, it renders the world accessible and helps us to come to terms with it. The main focus of this book will be on conventional linear perspective, though not at the expense of other equally important methods of projection. We need to retain a sense of the complexity of the way we actually see. This contrasts with the limitations of certain formalized systems of perspective. Linear perspective, for example, relies on a fixed rather than a constantly shifting viewpoint and on straight line projection to vanishing points. The more curvilinear reality

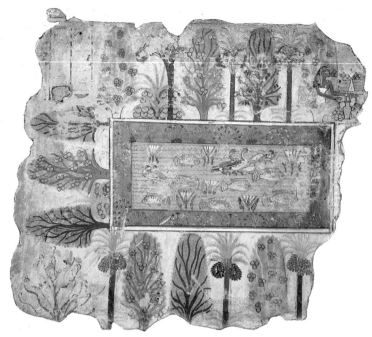

Egyptian fresco, *The Pool in Nebanum's Garden,* **c.1400** B.C.
The ancient Egyptian method of representation showed the scene from above, from the side and from the front at the same time. This opening out and flattening of the space gives an extremely clear view of the subject. The different views are all shown on one plane.

of our perception is denied. Linear perspective is based on the notion that the world is perceived as if existing behind a rectangular pane of glass, like a display case at the zoo. Such a system discounts the way we mentally

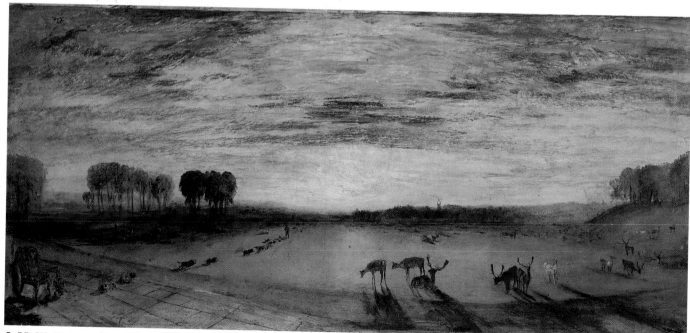

J. M. W. Turner, *Petworth Park,* **c.1828,** *60 x 146 cm (24 x 57 in)*
In this panoramic view, Turner has employed the conventions of one-point perspective. The lines of the shadows of the deer, the paving and the line of dogs all converge to a central vanishing point on the horizon immediately beneath the light source. But because he has chosen such a wide angle of view, Turner has also incorporated curvilinear perspective in the sweeping curves that replace the horizontals in the foreground and in the arching sky.

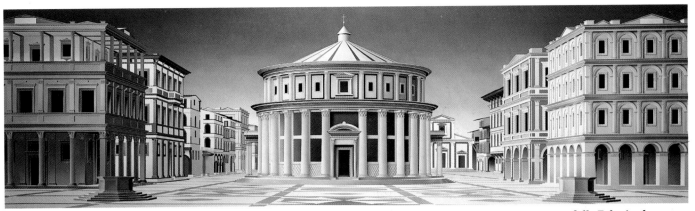

Ben Johnson, *Footfalls Echo in the Memory Down the Passage We Did Not Take Towards the Door We Never Opened,* **1993,** *1.37 x 4.88 m (54 in x 16 ft)*
Ben Johnson uses a computer to provide the perspective structure of his recreation of *The Ideal City*, attributed to Piero della Francesca.

enlarge whatever we are focusing on. In this book, we have concentrated on those aspects of perspective that will be of practical use to artists. So although there are pages that deal with some of the more technical aspects of perspective, this is not a strictly technical manual. We have tried to put perspective into context, to make the visual connection between a real image and whichever perspective construction is being featured. This includes the use of perspective drawing overlays on real images and, in the gallery pages, discussions of how artists have used perspective throughout history. The idea is to generate the confidence that helps us to understand the structure of what we are seeing and to recreate it in the sketchbook or on the canvas.

Child's drawing
There is a link between this child's drawing and the Egyptian image. We look down on both from above, with the subjects flattened to the picture plane.

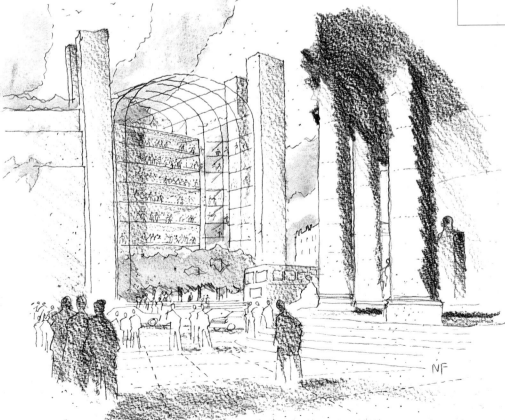

Norman Foster,
Drawing for BBC building
A good working knowledge of perspective comes into its own during the early stages of the design process. This sketch shows a confident facility in the freehand use of perspective that places the imaginary building within an existing context. It is important for an architect's client to be able to assess the scale of a building and the way it works within the available space. This is achieved here by the careful placing of figures. The foreground shading leads the eye into the focus of the sketch.

A BRIEF HISTORY

WHEN WE CONSIDER perspective historically, it is necessary to take a broad view. Within the various subdivisions of human history are a wide range of civilizations. Each has contributed to the ways in which we represent ourselves. No one system is more important or any more informative than another. Each approach adds to our understanding, and to our ability to come to terms with the world as it changes.

Different perspectives

Today, there is a more raised awareness of the different approaches to representation within diverse cultures, both past and present around the world. Artists can develop a focus for their own work from a wide range of stylistic and interpretative approaches within many alternative systems of visual representation. This freeing of former constraints has generated an exciting diversity of approaches to representation in contemporary painting.

The images on these pages give an indication of some of the many diverse methods of representing space and narrative. They could broadly be described as incorporating projection systems other than linear perspective. Such methods are similar to the orthographic, axonometric and isometric projection systems (*see* pp.70-71) employed by architects and engineers. These methods are invariably favoured over linear perspective drawing since they can provide such clear, self-explanatory images. There is no convergence to vanishing points and therefore none of the foreshortening that diminishes the size and detail of what you see. Such clarity can be seen in each of

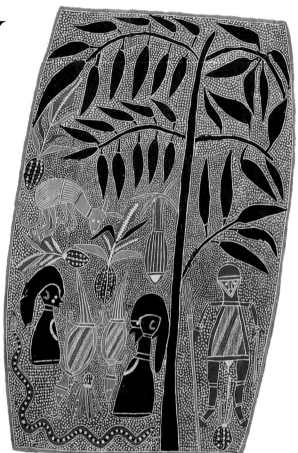

David Malangi, Mortuary Feast of Gunmirringgu the great ancestral hunter, 1963, *69.5 x 43 cm (27 x 17 in) In this modern Aboriginal painting, narrative elements are shown as plans or elevations (side and front) on the same plane, which is the surface of the bark. Each element is clearly recognizable and has its own unique symbolism.*

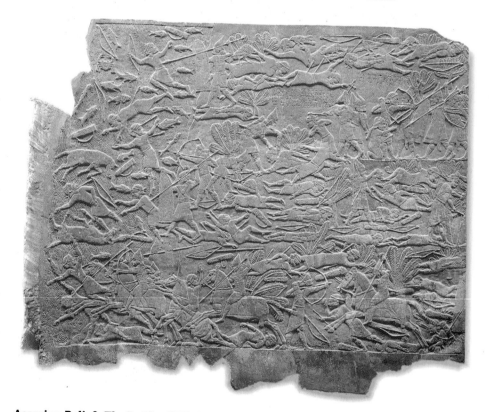

Assyrian Relief, *The Battle of Til-Tuba,* c.660-650 B.C., *1.47 x 1.75 m (58 x 69 in) The vigour and ferocity of this battle scene is a direct result of the system of representation* adopted by the sculptor. *We readily accept the convention that all the figures are projected the same size and from a similar viewpoint, and that the ground plane is the surface of the stone.*

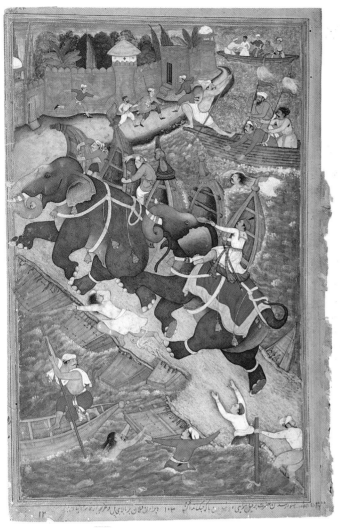

Miniature from the Akbar-nama of Abul Fazl, **c.1595,** *35 x 22 cm (14 x 9 in) In this example of late Mughal painting, the main feature of the composition is the dynamic central diagonal of the two elephants thundering across the pontoon bridge. They are two-dimensional, but painted with great vivacity. If the viewpoint were the same for them as for the boats that make up the bridge, we would be looking at elephants lying on their side. However, we get a clear aerial view of the boats, which demonstrates their function perfectly and a view of the elephants that gives us all the information we need. Unlike the Assyrian image, here the size of the figures diminishes with distance.*

these works and particularly in the Japanese painting and Assyrian carving, where each of the figures is shown to the same scale and has equal weight in the composition. In the Mughal painting, whilst the image has a similar directness and immediacy, the structure of the work has not been defined solely by the conventions of its own culture, it has absorbed some perspective elements from Western painting – for example, with the progressive diminution of the figures and boats into the distance.

The seeds of linear perspective

The ancient Egyptians and Assyrians were able to represent their world quite satisfactorily on one plane. Figures could be seen frontally, from the side or in three-quarter view at the same time, and varied in size according to their importance. The correlation between size and importance also found expression, from the fourth century onwards, in Byzantine art, with its flat, iconic images.

According to the Roman architect and engineer Vitruvius *(1st century B.C.),* the ancient Greeks were the first to explore the notion of the recession and projection of images in order to give the illusionistic appearance of buildings in painted stage scenery. There are a number of Greek and early Roman frescoes that show a considerable degree of spatial illusion and in which the sides of an object are shown receding at an angle, though they do not converge. The Room of the Masks on the Palatine in Rome is a fine example of the attempt to create a convincing architectural setting in parallel perspective on a two-dimensional wall. But in the West, the use of even rudimentary perspective died out for many hundreds of years until its revival in thirteenth-century Italy.

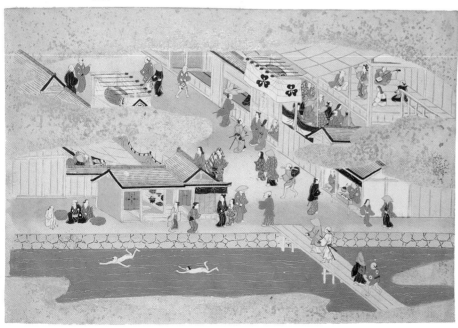

Tosa-Sumiyoshi School, *Entertainments in Kyoto,* **c.1661-72,** *21.5 x 32 cm (8¼ x 12½ in) This painting is a fine example of oblique projection. The front faces of the buildings are* undistorted elevations, while the top and sides all project at the same angle. There is no convergence of parallel lines, so the figures retain the same size at any point in the painting.

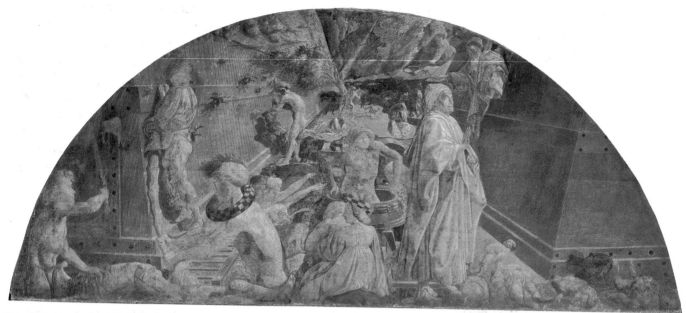

The Western tradition

In the post-classical Western tradition, linear perspective was first clearly demonstrated in Florence during the early fifteenth century *(c.1413)* by Filippo Brunelleschi *(1377-1446)*. His paintings of the Baptistery and of the Palazzo de' Signori in Florence, perfectly matched the proportions of the real buildings. Brunelleschi is said to have worked out his system through observation and the use of his surveying skills. He may even have projected his perspectives from plans and elevations. Leon Battista Alberti *(1404-72)* was the first to give a formalized account of a perspective system, known as the *costruzione legittima,* based on a *pavimento* (pavement) grid of perspective squares *(see* p. 20). Using Alberti's system, artists were able to put a grid over the plan of an object and transfer the lines of the object onto a similar grid in perspective. Heights could be established either by swinging a vertical up from the horizontal floor grid at the appropriate point in the perspective drawing, or by using a vertical grid in addition to the horizontal one.

Artists like Paolo Uccello *(1397-1475)* and Piero della Francesca *(1415/20-1492)* were aware of the

Paolo Uccello, *The Flood,* **c.1445**
Uccello has exploited his mastery of the art of perspective by using it to show the vastness of the ark as it recedes on the left towards a central vanishing point on the high horizon line. In order to avoid a completely symmetrical image, Uccello has placed the wall on the right at a slightly different angle to the picture plane from that of the ark on the left, so that they do not share the same vanishing point.

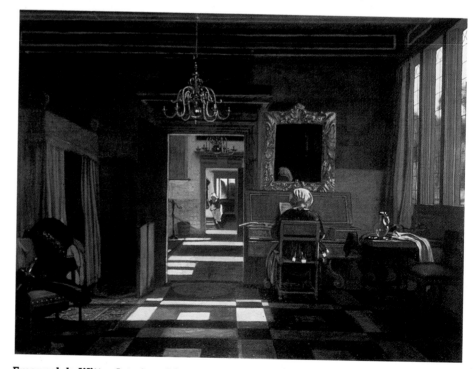

Emanuel de Witte, *Interior with Woman at a Clavichord,* **c.1665,** *77 x 104 cm (30 x 41 in)*
In this fine example of one-point perspective, the eye is led through the house to a central vanishing point beyond the far window. The artist has used the patches of light from windows along the right of the house to break up the composition's symmetry and add visual interest along the ground plane.

limitations of the grid method. Painter and art historian Giorgio Vasari *(1511-74)* describes how Uccello preferred to work by projection from plans and elevations. Piero employed a complex system of projection based on Euclidean geometry. His paintings have a sense of order and serenity that stems from the spatial precision of their composition.

Among the artists who furthered study of the new art of perspective were the great German painter Albrecht Dürer *(1471-1528),* who wrote treatises on the subject, and Diego Velázquez *(1599-1660)* who held a significant collection of writings on

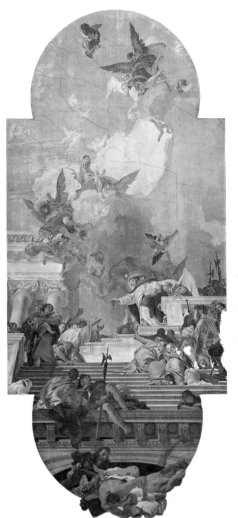

Gian Battista Tiepolo, *The Institution of the Rosary*, c.1737-39

From the sixteenth to the eighteenth centuries, illusionistic wall and ceiling painting developed towards the dazzling trompe l'oeil *works of Tiepolo. Perfectly foreshortened figures freewheel in space above settings of entirely convincing painted architecture.*

Jan Dibbets, *Spoleto Floor*, 1982, *1.7 x 1.75 m (5 ft 7 in x 5 ft 9 in)*
Jan Dibbets' seminal Perspective Correction *piece of the late sixties undermined the very notion of linear perspective. Here, the curvilinear or spherical approach to perspective representation gives a convincing view, though we are constantly aware of the flat surface of the paper.*

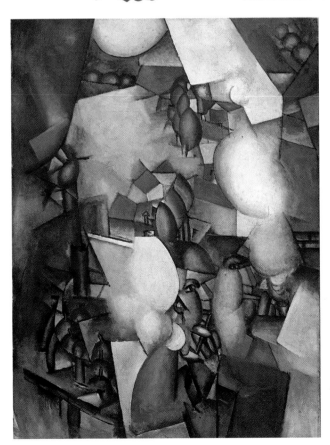

Fernand Léger, *Smokers*, 1911,
130 x 96 cm (51 x 38 in)
In this cubist work, the surface is a pattern of interlocking planes, but the scale of individual elements gives a sense of distance and movement. While the planes are broken up, there is still a genuine sense of perspective. There is too a play between the clouds of smoke and clouds in the sky.

perspective. But it was Leonardo da Vinci *(1452-1519)* who made the greatest advances in the subject.

Leonardo is perhaps the one artist the extent of whose genius allowed him to explore the implications of perspective as it related to how we see and experience the world. He was the first to suggest the anomalies of linear perspective, particularly in his observations on wide-angle views and the cone of vision.

It is possible to trace a growing sophistication in the handling of perspective throughout the history of Western painting. From the experiments of Renaissance Florence to the complex Baroque illusionism of the late sixteenth century, linear perspective has been increasingly manipulated to convince the viewer of the truth depicted on the painted surface. A break in this process occurs with the abandonment of realist painting at the end of the nineteenth century and the advent of photography. With the spread of photography, many artists began to create paintings in which they aimed to break up the picture plane itself. In many cubist and futurist paintings, the fragmentation of the image is itself the means of creating meaningful perspective.

Curvilinear perspective
The idea of curvilinear perspective developed by Leonardo in his optical theories has appeared in the work of many artists. From the early fifteenth-century paintings of Jean Fouquet *(1420-81)*, through nineteenth-century Romantic expressions of space in the landscapes of Turner *(1775-1851)* and John Martin *(1789-1854)*, to the interiors of Van Gogh *(1853-90)* and the work of David Hockney *(b.1937)*, curvilinear perspective is an approach to the depiction of space that many artists of our time have re-discovered.

STARTING OUT

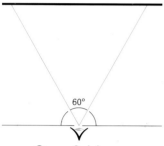

Cone of vision
To avoid distortion, any object we wish to draw must fall within a 60-degree angle of vision.

WHEN WE BEGIN drawing or painting, it can be difficult to decide just how much of what we can see should be put down on the paper or canvas. We focus on the scene in front of us, but at the same time we are aware of objects at the periphery of our vision. There is a sense in which we can see all around us. If we consider how much we can represent within the limitations of a conventional perspective approach, we will realize that it is extremely difficult to get the whole scene into our painting. We need to be selective, to narrow the angle of vision so that our painting might focus on only a fraction of what we see.

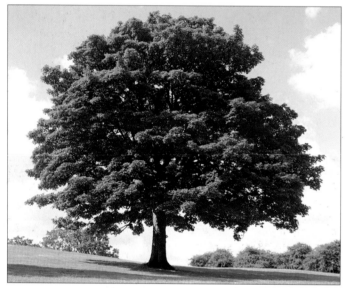

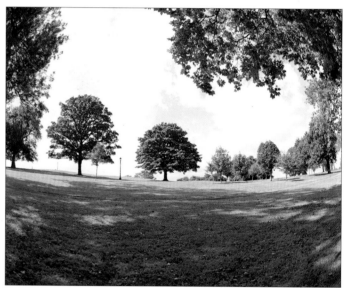

Selecting your subject

When standing in a landscape, we are conscious of the whole scene that surrounds us. We can focus on one part of the landscape, like the tree above left. We can make a drawing or painting of something that can be comfortably included within a relatively narrow angle of vision. Or we can attempt to give expression to a much wider view. In the photograph above right, we are aware of trees curving in towards us, to the left and right, at the periphery of our vision, and of the ground close to our feet. In the middle distance, a row of trees is clearly defined. Conventional linear perspective works without the distortion seen in the right-hand photograph because subjects are generally contained within a 60-degree angle or cone of vision.

Hallway scene

A hallway is generally a rather narrow and vertical space. But here the artist has managed to fill the square format of her page with a convincing impression of all that the interior contains. The view is generally one of linear perspective, but at its edges the image begins to curve slightly as the limits of the cone of vision are reached.

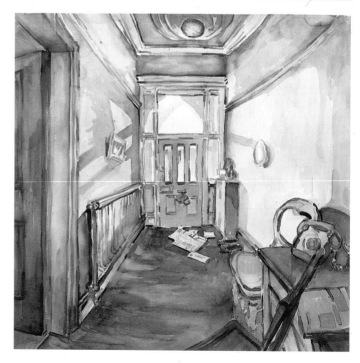

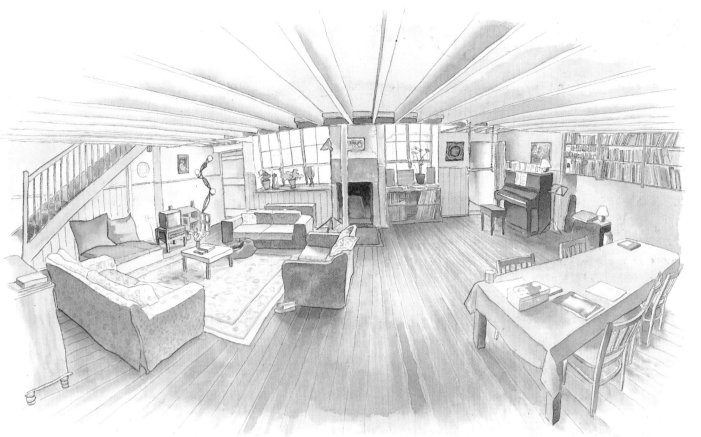

Natural perspective

In this drawing of a large room, the artist has tried to represent the objects seen out of the corner of his eye to left and right, in addition to the space in front. The sofa and chest (bottom left) are in reality parallel to the table (bottom right). In certain types of perspective drawing, the back of the sofa and the edge of the table, which are at right angles to the floorboards, would be drawn along the same horizontal line. Here, they are at an angle to each other because that is how you actually see them. Similarly, the central beam across the ceiling is in reality straight and would be drawn so according to conventional perspective, but when you look at it, it appears curved.

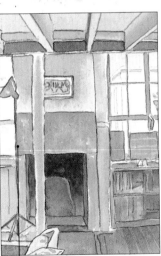

This section appears as it might in linear perspective before any distortion outside the cone of vision.

This tiny study shows a more conventional view through the car windscreen taken from the same position. In the larger drawing, the church can be seen above the girl's right elbow.

Wide-angle view

This simple sketch encompasses an extremely wide angle of vision. It could not be made using conventional linear perspective because the cone of vision is too wide, but it does demonstrate that a drawing taking in such a wide angle of view can generate a real sense of involvement and of place.

THE PICTURE PLANE

Start with a small subject

THE PICTURE PLANE IS THE CANVAS or sheet of paper on which you draw. It is possible to imagine the picture plane as a sheet of glass through which light rays from the object pass on their way to the eye. When you make a drawing in perspective, the objects that are marked on your canvas are shown as they would be seen when viewed through a transparent surface. If you make some drawings on a glass of the view seen through it, you will see for yourself some of the basic principles of linear perspective drawing.

Equipment

A sketching glass of around 20 x 25 cm (8 x 10 in) is suitable. You should hold the frame rigidly on the table and use a pigmented felt-tip pen, a brush and ink or an all-purpose pencil to draw on the glass.

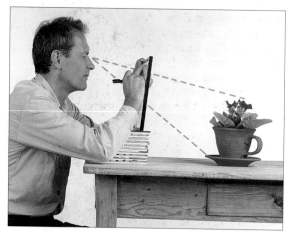

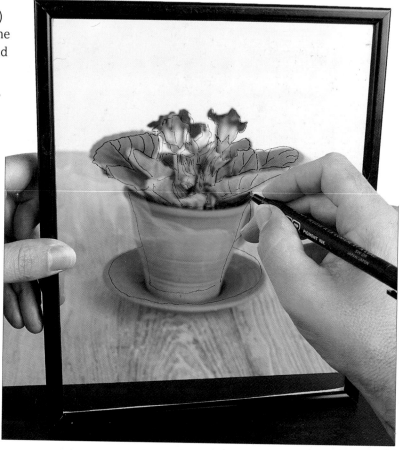

1 ▲ Close one eye and try to keep your head in the same position. As you draw, you may find the image wobbles around, as it is difficult to keep yourself and the glass still and draw at the same time.

2 ▶ If you use a sheet of glass in a frame you can hold, such as a small photo frame, you can alter your composition. The closer you move the frame towards the subject, the bigger the subject will appear on the glass.

Transferring your image
By laying a piece of damp paper on the glass, you can transfer a reverse image of what you have drawn.

Peeling back
Peel the paper off and you will find that the image has been transferred. To reverse the image, redraw the image on the back of the glass.

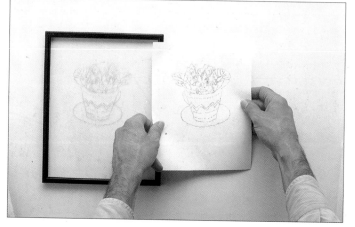

Composing your picture

Drawing on glass will help you to try out poses and angles for portraits, in addition to achieving reasonable likenesses.

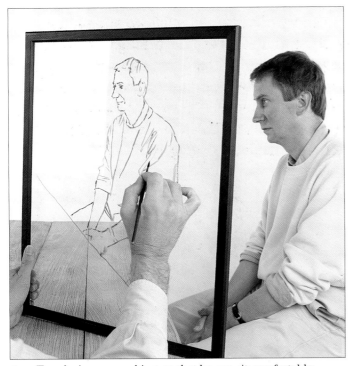

1 ▲ Try placing your subject so that he can sit comfortably without moving. The combination of your slight movements and those of the model can make it difficult to keep the image correctly lined up with the subject as you draw on the glass.

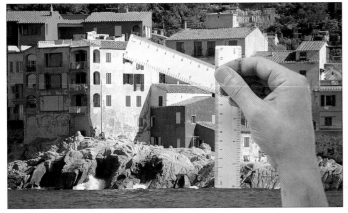

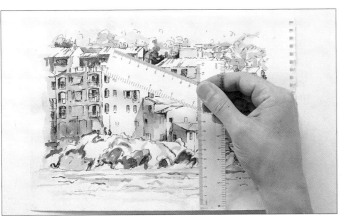

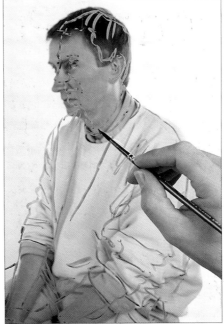

2 ▲ If you use a soft pointed sable or nylon brush with Indian ink, you will get the best results by tracing the lines and features of what you see through the glass freely and economically rather than being overly cautious in your approach. You can "print" the images as you draw them, using the technique described opposite. Out of a number of rapid sketches you will generally find one or two that work successfully.

Materials

Fine felt-tip pen

Size 4 round sable brush

Picture frame

Measuring your composition

You can use a pencil held out at arm's length to measure the size of a subject as you see it. A similar method with two rulers can be used to assess the angles of various parts of the image in relation to the picture plane. A simple rectangle of cardboard, with a smaller rectangle cut out of the middle is often used to define a composition and help show what might be included in a painting. Hold it in front of you and then try to draw what you see through the "window" in the card. If you mark off a scale along the edge, it is relatively easy to see where a significant line, such as the horizon line, or the top of a building, bisects the edge of the card.

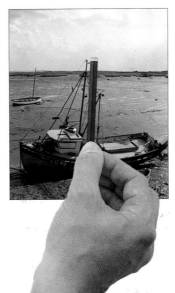

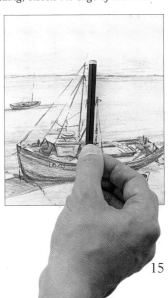

15

HORIZON OR EYE-LEVEL

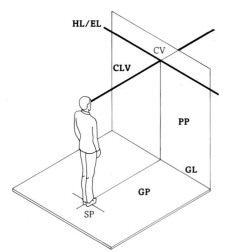

LINEAR PERSPECTIVE DRAWING is based on certain fundamental principles and a grammar of straightforward technical terms that relate the subject of the drawing to its image on the picture plane. These terms are important and useful to artists whether or not they wish to make technical perspective drawings. One of the first elements in a picture that the artist will need to establish is the Horizon Line (HL) or Eye-Level (EL), which is the line at which the sea and sky appear to meet. It is important to know where it is, even if it is obscured by hills or buildings. The horizon line is always drawn straight, even though the earth is curved, as we are only ever drawing a small section of it.

Technical terms

The Ground Plane (GP) is the level ground upon which the artist is apparently standing in order to view a scene; it stretches to the horizon. The exact point where he stands is the Station Point (SP). The Ground Line (GL) represents the bottom edge of the picture plane where it cuts the ground plane. The Centre Line of Vision (CLV) represents an imaginary line from the artist's eye to the horizon at 90 degrees to the Picture Plane (PP). It intersects the horizon line on the picture plane at the Centre of Vision (CV).

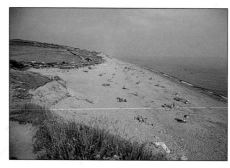

View from a cliff

Whatever your position in the landscape, if you look straight ahead and do not tilt your head up or down, the horizon line will always be at your eye-level. In this view from a high cliff-top, you see considerably more of the ground below the horizon than if you were standing at sea level.

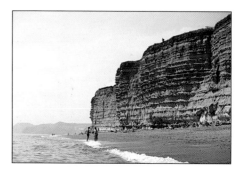

View from a beach

Here, you are standing on the beach at the edge of the sea, so the horizon line is low. You see a great deal more of the sky than in the image on the left. A distant figure of the same height standing on the same level would be bisected by the horizon line at the level of the eyes.

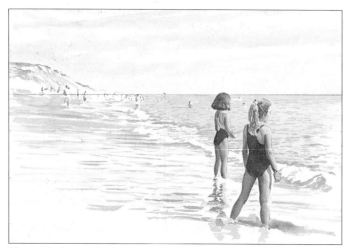

Normal viewpoint

These three paintings demonstrate how the position of the horizon line can affect our reading of a painting. Here, the artist's eye-level roughly matches that of the children. The effect is to allow the viewer to participate in their experience and our eye is drawn with theirs to the distant horizon line.

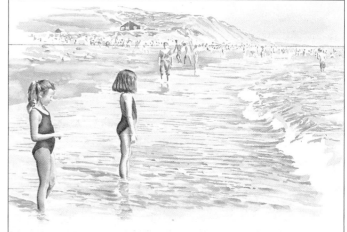

High viewpoint

In this painting, the standing artist is taller than the children and his eye-level is thus higher than theirs. The higher horizon line means we see more of the beach, while the girls themselves appear smaller and more vulnerable. The artist is more an observer than a participant.

Cone of vision

If you look at a scene from a fixed viewpoint without moving your head, your eye can only take in a certain proportion or segment of it without losing focus or encountering distortion at the edges of our angle of vision. For the purposes of linear perspective, we try to ensure that the subject comes well within an angle or, in three-dimensional terms, a cone of vision of up to 60 degrees. Anything seen from within that angle can be represented without perceived distortion. When drawing a tall building, we need to take particular care to set the station point sufficiently far away to ensure that its height comes well within the cone of vision.

HL/EL

HL/EL

PP

GL

GP

SP

Converging rays

The diagram shows how a 60-degree cone of vision encompasses a beach scene. Where rays of light from the objects intersect with the picture plane, the scene would be depicted on the picture plane in linear perspective; the rays converge at the eye of the viewer. An artist would commonly choose to make a painting on a rectangular format from within the cone of vision.

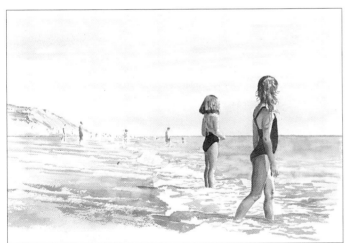

Low viewpoint

Here, the artist has adopted a very low viewpoint and his eye-level is much lower than that of the children. The image appears quite different from the previous ones and the children become much more independent and prominent. There is a sense of their ordering or controlling the scene.

ESTABLISHING THE HORIZON LINE

Since the horizon line is the principal location of vanishing points for objects on the ground plane, it is essential to know where to place it in your painting. You will not always be able to see the horizon – it may be concealed by a wall or by a mountain range, for example. Below are two methods for establishing the horizon line. In the first, there is no object or surface in front of you to mark. In the second, there is.

Open space	*Foreground object*
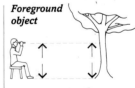	

If there is nothing to physically mark your eye-level on the scene in front of you, place a stick or cane in the ground and mark it at the level of your eyes.

Hold the edge of a sketchbook or credit card up at eye-level.

Plant the stick in the ground some distance in front of you. Make sure it is on ground that is level with that on which you are standing.

Make a chalk mark on the object – here, the trunk of a tree – at the same height as the card or book.

Note where the height of the stick corresponds with a distant feature and draw in your horizon line.

The chalk mark will show where the horizon line would cut across the scene and where it will be in your picture.

17

THREE VIEWS ON PERSPECTIVE

PERSPECTIVE DIAGRAMS MAY APPEAR to bear little relation to the world we see. When an artist sets out to make a painting, it is unlikely that the subject will be a cube set parallel to the plane of the canvas, or at any specific angle to it. But once the principles of perspective have been absorbed, it is surprising how helpful they can be in constructing a framework on which to build a painting. It may be helpful to consider linear perspective construction as one-point, two-point or three-point, based on the number of principal vanishing points in the construction.

One-point perspective
All lines at right angles to the picture plane and parallel with the ground plane appear to converge at the same vanishing point on the horizon; this point is also the centre of vision.

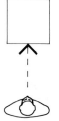

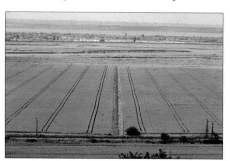

A cube is viewed with one side parallel to the picture plane

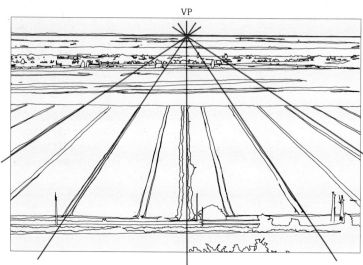

A cube is viewed at an angle to the picture plane (here each side is at 45 degrees)

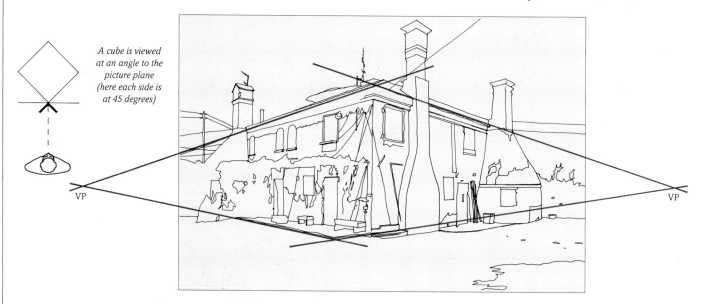

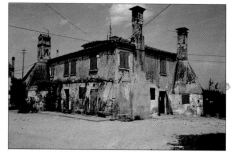

Two-point perspective
Each side of this house is seen at an angle of around 45 degrees to the picture plane. Assuming the house is a regular cube, you see each side appearing to recede symmetrically towards a vanishing point on the horizon line on the left- and right-hand sides of the image. The vanishing points lie on the horizon line because the base of the house is on the level ground plane and the top edges of the walls are parallel with it.

If you are standing directly opposite the front edge of the cube, then the vanishing points are equidistant from the point you are facing (the centre of vision). Find a simple building and try this out for yourself by making a simple drawing. Start with the vertical line of the front edge of the building and, using two rulers (see p. 15), assess the angles at which the sides of the building recede from it. Build up a complete image from these angles.

Two-point angular

The narrow boat has more of its stern facing the viewer than its side, so foreshortening in the long side appears to be greater. The vanishing point for this side is much closer to the centre of vision than that for the stern. We are describing a rectangle, and if we were to look at the boat from above, we would see the lines extending from these vanishing points to each side of the barge meet at an angle of 90 degrees. The subject, however, does not have to be rectangular; it need only have straight sides for a vanishing point to be established.

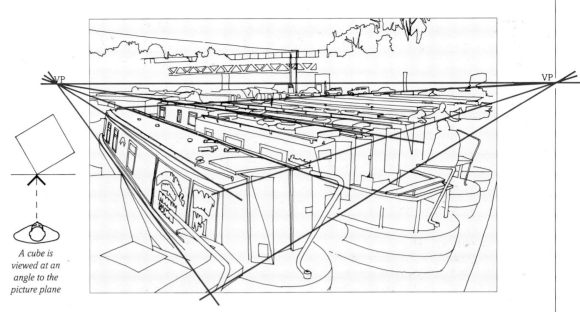

A cube is viewed at an angle to the picture plane

Further vanishing points

In any two-point construction, there can in fact be a number of vanishing points plotted in addition to the two principal ones that might be used – for example, to draw the front, back and sides of a house set at an angle to the picture plane. In the case of a house, these additional vanishing points would be used to draw any feature – such as an open window – that is at an angle other than that of the walls of the house itself. In the image above, for example, the front doors of the barges are clearly at a very different angle to the vanishing lines that are drawn in for the main body of the boats.

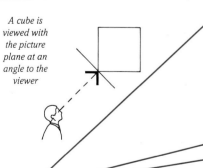

A cube is viewed with the picture plane at an angle to the viewer

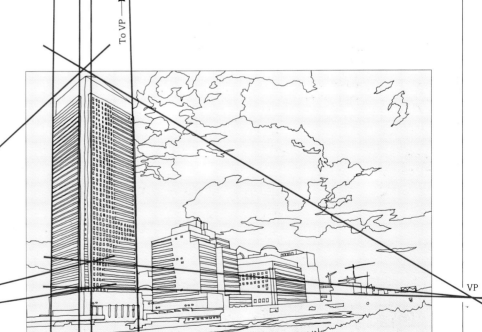

Three-point perspective

So far, either our images have had one side parallel with the ground plane or we have been sufficiently distant from them to be able to draw their vertical lines parallel with the left- and right-hand edges of the paper. But when the cube has none of its three planes parallel with the picture plane – like a box-kite in mid-air, for example – we need to establish a further vanishing point for the third plane. When a building is so tall or we are so close to it that its vertical sides begin to converge, we plot its construction in three-point perspective. The basis of three-point perspective is that no side of the cube needs to be set at right angles to the picture plane or to be parallel with it. In the image above, if we were to extend the vertical lines of the building, they would eventually join at a third vanishing point.

ONE-POINT PERSPECTIVE

ONE-POINT PERSPECTIVE is based on a construction in which all parallel lines receding at right angles from the picture plane converge to a vanishing point at the centre of vision. All lines that are parallel to the picture plane remain parallel in the drawing, so the box appears both to retain its true shape and to diminish in size as it recedes into the distance. If you draw a cube with one face on the picture plane, the position of the back face of the cube on the ground plane must be established. This is usually done by constructing an additional diagonal vanishing point (or measuring point) on the horizon line.

Foreshortening

Imagine looking across a courtyard of square slabs in which two parallel sides of the slabs recede away from you in a straight line towards a central vanishing point and the other sides recede horizontally. The apparent distance between the lateral or horizontal edges will get progressively smaller. This is known as foreshortening.

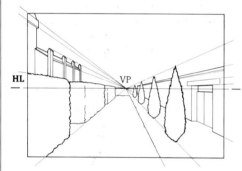

Convergence
The diagram on the left shows how parallel lines at right angles to the picture plane converge at a central vanishing point. Objects of equal height, such as the trees, look smaller the farther away they are.

Railway track
The farthest of the railway sleepers looks smaller because rays of light from each side of the sleeper begin to converge on the eye of the viewer from farther away. By the time they reach the picture plane, the distance between them is smaller than for the others.

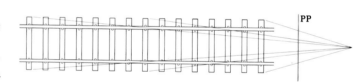

Pavement method

One-point perspective can be shown using a pavement or grid of squares. The front edge of this pavement is the ground line. Since this is the lower edge of the picture plane, the pavement can be used to establish scale. Draw the horizon line to scale at a suitable height (the height of a person). All parallel lines receding at right angles from the PP converge at the same VP on the horizon midway across the pavement. Join the point on the GL to the VP to give the orthogonals (*see* below).

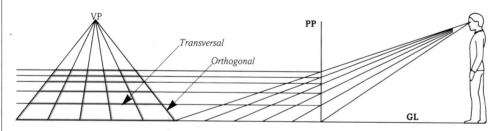

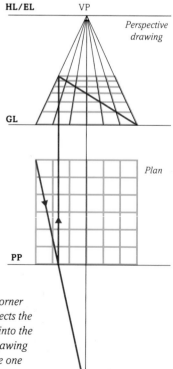

Alberti's method (*above*)
Alberti (see p. 10) constructed a side view showing the picture plane side-on, the viewer to the right and the pavement to scale along the ground plane. Rays of light pass from points on the pavement to the eye of the viewer. From the point of intersection with the picture plane, horizontal lines are drawn back to the original grid. Where they intersect the orthogonals determines the position of transversals (horizontals) on the grid.

Finding the transversals (*right*)
Plot a line from the station point to the farthest corner of the plan. From the point where that line intersects the picture plane of the plan, carry a further line up into the perspective drawing. A line on the perspective drawing drawn from one corner of the grid to the opposite one provides the remaining points of intersection where the transversals (horizontals) cross the orthogonals.

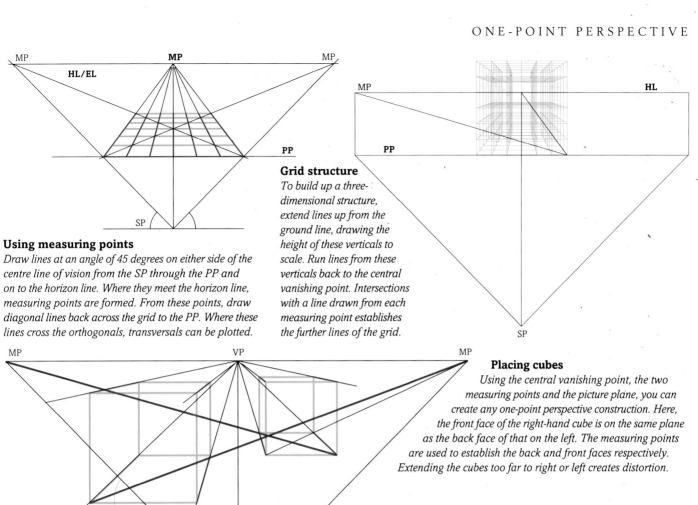

Grid structure

To build up a three-dimensional structure, extend lines up from the ground line, drawing the height of these verticals to scale. Run lines from these verticals back to the central vanishing point. Intersections with a line drawn from each measuring point establishes the further lines of the grid.

Using measuring points

Draw lines at an angle of 45 degrees on either side of the centre line of vision from the SP through the PP and on to the horizon line. Where they meet the horizon line, measuring points are formed. From these points, draw diagonal lines back across the grid to the PP. Where these lines cross the orthogonals, transversals can be plotted.

Placing cubes

Using the central vanishing point, the two measuring points and the picture plane, you can create any one-point perspective construction. Here, the front face of the right-hand cube is on the same plane as the back face of that on the left. The measuring points are used to establish the back and front faces respectively. Extending the cubes too far to right or left creates distortion.

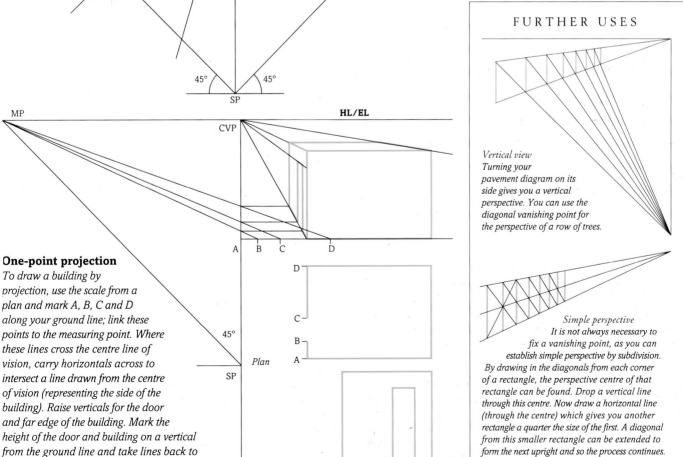

One-point projection

To draw a building by projection, use the scale from a plan and mark A, B, C and D along your ground line; link these points to the measuring point. Where these lines cross the centre line of vision, carry horizontals across to intersect a line drawn from the centre of vision (representing the side of the building). Raise verticals for the door and far edge of the building. Mark the height of the door and building on a vertical from the ground line and take lines back to the centre of vision to establish their height.

FURTHER USES

Vertical view
Turning your pavement diagram on its side gives you a vertical perspective. You can use the diagonal vanishing point for the perspective of a row of trees.

Simple perspective
It is not always necessary to fix a vanishing point, as you can establish simple perspective by subdivision. By drawing in the diagonals from each corner of a rectangle, the perspective centre of that rectangle can be found. Drop a vertical line through this centre. Now draw a horizontal line (through the centre) which gives you another rectangle a quarter the size of the first. A diagonal from this smaller rectangle can be extended to form the next upright and so the process continues.

CURVES & CIRCLES

PUTTING CIRCLES INTO perspective is simple, if you bear in mind that a circle fits perfectly into a square, with its edges touching the square at the mid-points of the square's four sides. It follows that you need only to put a square into perspective at the appropriate angle and then construct the circle within the square. A circle in perspective is an ellipse. The mid-point of an ellipse does not correspond to the mid-point of the same circle in plan, but is mid-way between the extremities of the ellipse on its major (longest) and minor (shortest) axes.

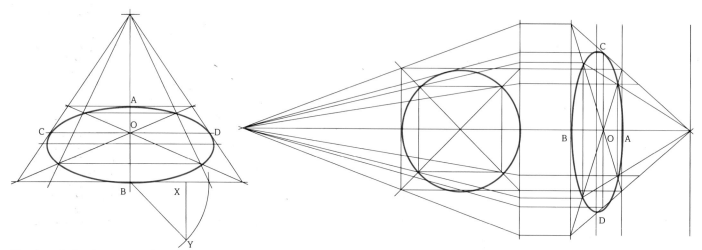

Putting circles in perspective

Put a square in perspective (see pp. 20-21). The centre of your circle lies at the intersection of the diagonals (O). Draw a vertical line (AB) and a horizontal line (CD) through this point parallel with the edges of the square to establish four points (A, B, C, D) at which the circle touches the square. Measure a quarter the length of the square on the picture plane from its mid-point (BX). Drop a vertical line the same length (XY) and, using the mid-point as centre, describe an arc to cut the front of the square on each side. From these points, draw lines back to the vanishing point. Where they cut the diagonals from each corner, they will intersect with the line of the circle. The additional points of guidance for the drawing of a circle within a square are shown by measurement. They can be established by projection from a plan (see pp. 30-31, 38-39). The diagram on the left can be adapted to the requirements of your subject. In the diagram above, you are projecting across from the plan on the left to the perspective drawing on the right, as is the case with the motorbike below.*

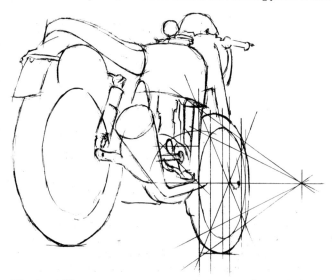

Placing ellipses

In this diagram for the acrylic painting on the right, the circle is on a receding vertical plane so the major axis of the ellipse is a vertical line, while the minor axis recedes to the vanishing point on the horizon.

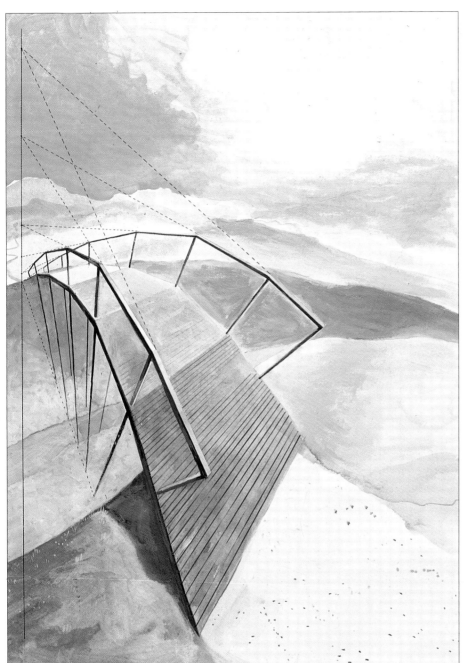

Curves as straight lines

The perspective of a curve can be established, as here, by rendering it as a series of inclined planes (see pp. 36-37). If you were to look at this bridge from above, you would see the sides of the bridge are parallel. Whether the planes of the walkway and the matching angles of the handrails are ascending or descending, they all share the same vertical vanishing axis (left). You might continue the construction all the way round to show a waterwheel, or in a switchback fashion, as in a rollercoaster. The principle is that curves are often best represented by the use of straight lines.

CHANGING VIEWPOINT

The viewpoint adopted determines the angle of the ellipse and therefore the length of the vertical axis. Where the horizon line is level with the top of the glass, the circle will appear as a straight line.

Seen from a mid viewpoint, the ellipse of the glass rim is very shallow. The smaller axis – here the vertical axis – corresponds to that with the greatest distortion.

A higher viewpoint produces a larger minor axis. Here, this is the vertical axis. The subject is further distorted by the refraction caused by the thick bottom of the glass.

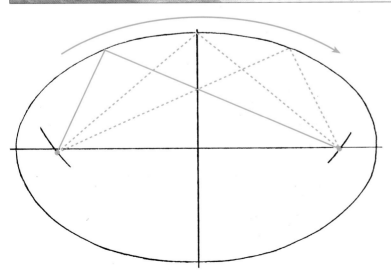

Drawing an ellipse

Draw the major axis of the ellipse and the minor axis at right angles to it. Open your compass to the length of half the major axis and, using the extremity of the minor axis as a centre, describe an arc to cut each side of the major axis. Put a pin in each of these points and knot a circle of thread, looping it over the pins and pulling it taut to ensure that it reaches the end of one of the axes. Put your pencil in the loop and draw the ellipse. A clutch pencil works well, as does a technical pen.

23

ATMOSPHERIC PERSPECTIVE

ATMOSPHERE AFFECTS the way we perceive tones and colours as they recede towards the horizon. An understanding of atmospheric or aerial perspective will give your work a greater illusion of depth not simply in relation to landscape but with any subject. Tones lighten and colours become cooler or more blue with distance, warm colours advance, while cool colours recede. In misty weather, the lightening of tones in the receding planes of a landscape is particularly marked. Similarly, from a high vantage point on a sunny day, you can see how easily the green colours of a landscape become progressively blue towards the horizon.

Receding tones

You can imagine the landscape as a series of vertical, receding planes. Each of these planes is the same tone in nature, but the effects of atmospheric perspective mean that the farther they are from the viewer, the lighter they appear to be.

Landscape tones

If you look straight through them, you can see the effect of the receding tones as they appear in the landscape. Notice how in the diagram on the right your angle of vision can take in more of the landscape as it opens out towards the horizon.

Tonal watercolour

In this painting, based on the photograph left, the dark tones of the foreground trees are continued in the pale grey tones of the distance. Similar purely tonal paintings can be made in which you begin with the lighter, distant tones and end with the almost black silhouettes in the foreground. Here, the two distinct tones represent middle distance and foreground.

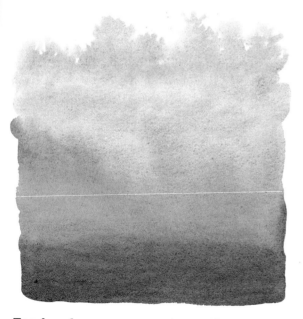

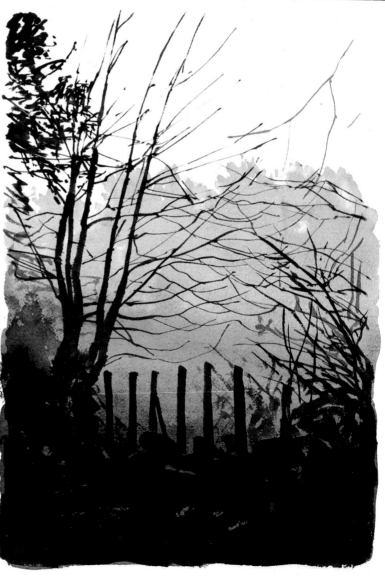

Tonal washes

A diluted wash is painted up to the line of the trees at the top. When dry, the darker tones of the trees can be painted over.

Receding colour

These diagrams are set out in the same way as those opposite. They show how, together with the lightening of tone, colours become cooler as they recede. The same colour green in each one of four receding fields appears to become more blue towards the horizon.

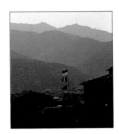

Atmospheric view

The photograph on the left clearly shows the effects of atmospheric perspective, from the dark tones of the village in the foreground to the lighter blue tones of the distant hills. This photograph has been used as the basis for a series of freely painted watercolour studies that explore the combined effects of tone and colour in the landscape.

Colour contrast

In this preliminary step, the artist has concentrated on colour, juxtaposing the yellow-blues of the distant hills with deeper-toned red-blues in the buildings. The effect is of sun in the distance with the foreground in cooler shadow.

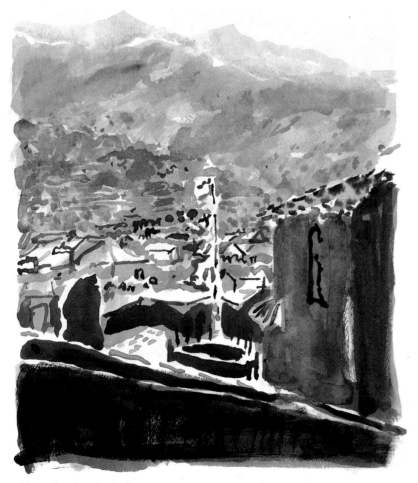

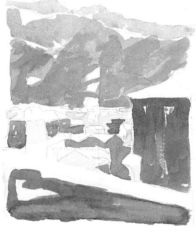

Preliminary stage

Warmer ochres representing the town separate the greys of the foreground from those of the hills, creating a sense of depth.

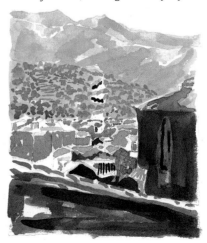

Changing brushstrokes

The effect of perspective can be accentuated by the use of different brushstrokes. Here, bold, deep-toned brushstrokes in the foreground move through smaller, more precise strokes in the middle ground to broad washes with no detail in the far hills.

Receding planes

Foreground roofs and tiles give way to middle ground trees and distant slopes.

DETAIL & DEFINITION

Here, aerial perspective is interrupted in the middle ground by brilliant sunlight

THE CRISP BLACK LINES of technical perspective drawings may show the apparent diminution in the size of objects as they recede into the distance, but they do not show how the image becomes progressively less distinct. Of great importance to artists is the effect of atmospheric perspective on our perception of detail. Such changes have to be reflected in modifications to the techniques we use to represent objects over distance. The progressive diminution of tone and cooling of colour with distance is a good general rule.

Loss of detail

The photographs on the right show the same subject from two different distances. In the left-hand photograph, the subject's head is relatively close to the camera and as a result the image is very clear. In the image on the right, the blurring effect caused by atmospheric perspective has altered the definition of the face. The photographs below the two faces show the position of the camera in relation to the subject. Loss of definition is greater with the human eye than with a modern camera.

Facial features

A painter working close-up to a model might want to record the clarity and fine detail that is plainly visible, but from a distance such details cannot be seen and so the approach needs to be broader, reflecting the general shape and the overall tonal contrasts. One of the mistakes artists can make when starting out is to try to add detail to parts of an image in the middle ground or distance. This is particularly the case with images of people and it can look very odd where a head is too tightly painted in comparison to everything that surrounds it. You need to focus on what you actually see rather than what you think you can see. Often features can be marked in with one or two light strokes.

Excluding detail

When depicting part of an image in which detail has been lost due to the effects of atmospheric perspective, you often retain a strong impresssion of the object seen. One of the simplest ways of overcoming the problem is to half close your eyes to blur the focus a little. This will enable you to concentrate on just the basic forms.

Weight of line

The lightening of tone associated with distance in atmospheric perspective does not always have to be expressed in tonal shading. It is quite possible to show the effect by using line alone. In this line drawing of figures on a beach, the artist has used a lighter weight of line in the distance, giving a good sense of receding space. The detail below shows diminution of detail with distance. We accept that these are people far away even though we can barely make them out.

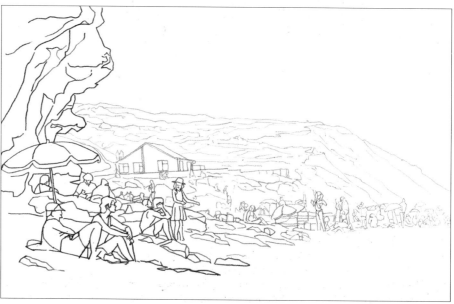

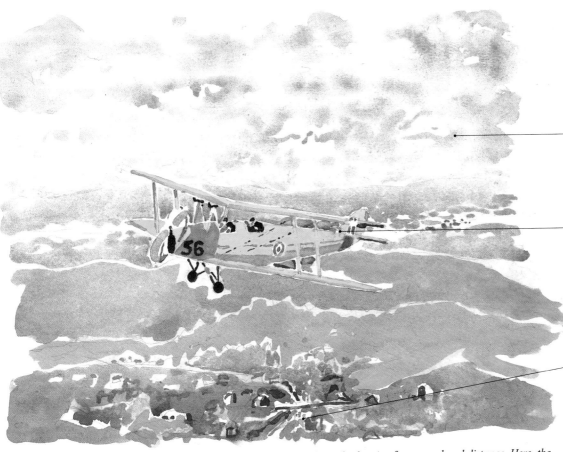

With watercolour, one way of softening the tones in the distance is to wash the whole painting, protecting certain areas with art masking fluid.

The effective contrast between blue and yellow enables the aeroplane to stand out from the background.

A few simple geometric touches of deeper blue or red-brown are enough to indicate the buildings in the village below.

Leaving out the middle ground

One of the ways in which artists can create a dramatic sense of perspective in the landscape is by losing the middle ground and simply showing foreground and distance. Here, the aeroplane is the foreground object, while the backdrop of landscape and sky provides a single distant plane.

Cloud effects

An essential feature of atmospheric perspective in relation to landscape is the treatment of clouds. The photograph clearly shows the diminution in the scale of the clouds as the eye moves towards the horizon. But it also shows how much they do to give a real sense of space above the land mass. You can use clouds to suggest substantial depth in a small area of canvas.

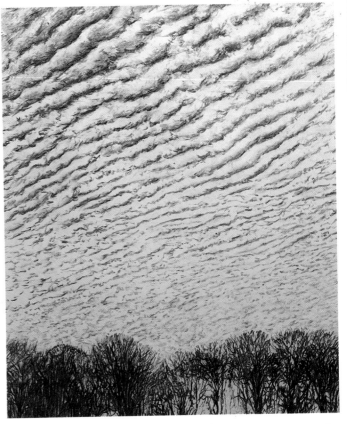

Clouds in perspective

The rules of perspective apply as much to clouds as to objects on the ground. There is a consistency in this mackerel cloud formation that makes the ridges appear uniformly closer and longer as they recede. Turn the page upside down and you could be looking at the ridges on mudflats.

GALLERY OF ATMOSPHERIC PERSPECTIVE

WHATEVER THE BROAD rules of atmospheric perspective may dictate, each situation is unique and has its own surprises. The diversity of these paintings shows how the effects of the atmosphere contribute to the illusion of perspective and how the artist can manipulate them to create a sense of structure and depth within a quite small area of canvas.

Nicolas Poussin, *The Burial of Phocion,* **1648,**
47 x 71cm (18½ x 28 in)
This idealized landscape has been composed with remarkable precision, taking the eye towards the centre of the composition and the distant architecture in a series of flat curves. The light, which heightens a rise in the ground here, or a part of the pathway there, breaks up the composition in a complex and intriguing pattern, sustaining our visual interest throughout the work. Towards the horizon, the artist has cooled the colours and lightened the tones almost imperceptibly in a classic example of aerial perspective.

The different sizes of the boats and subtle tonal variations beyond the waves reinforce the sense of receding space across the surface of the water.

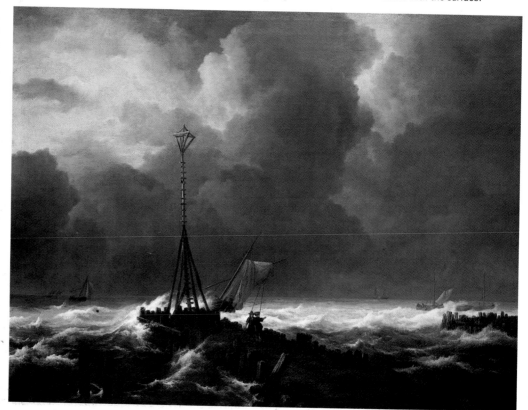

This detail is a miniature version of the whole composition. It also shows the care that the artist has taken with the surface.

Jacob van Ruisdael, *Stormy Sea,* **c.1655,** *98 x 132 cm (39 x 52 in)*
Here, the conventional view of a sky deepening in tone at the top and getting lighter towards the horizon is turned on its head. The depth of tone in the clouds towards the horizon gives a remarkable sense of the sky pushing down on the scene. The vertical post reaches up towards the sky, giving a sense of the huge expanse of space where a break in the clouds is visible. On the left-hand edge of the post, the white line indicates the light coming through these clouds and illuminating the seas just beyond the breakwater. The scene is pinned to the bottom edge of the painting by the heavy, dark tones of the foreground with the silhouettes of the breakwaters. One of the most remarkable achievements of this dramatic work is the sense of space the artist has managed to convey in the few centimetres between the white waves and the horizon.

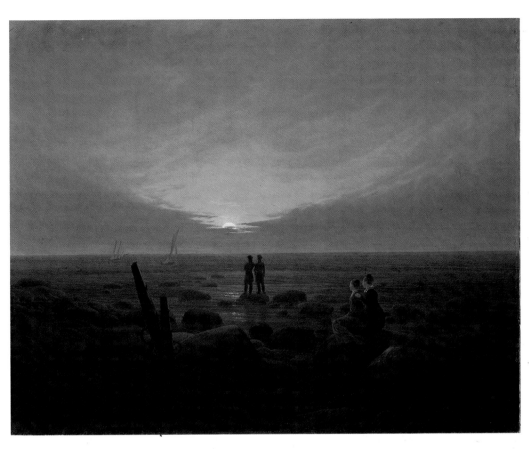

Caspar David Friedrich,
Moonrise over the Sea, **1821,**
1.35 x 1.7 m (53 x 67 in)
As you look at this painting you share a similar eye-level to the two men standing on the rock in the middle ground. Hence there is a link between the viewer's experience and theirs. They stand at the apex of a triangle that includes the seated women on the right and the driftwood sticking up on the left. This triangle is echoed above in an inverted and softened form by the arch of the clouds on each side of the moon, creating a quiet, almost elegiac atmosphere. Triangular elements in the composition form a stable structure within the painting, but they also relate to the vanishing lines of a perspective drawing and thus create a real sense of space. Towards the line of the horizon, the clouds become gradually paler in tone as they approach the light. This graduation in tone and colour forms an important component of the atmospheric perspective.

Bill Jacklin, *Before the Hurricane,* **1988,**
1.98 x 1.98 m (78 x 78 in)
Jacklin's painting sets up a tension between surface and depth. The diagonals of rain shafting across the image are so evidently painted in the foreground that they seem to represent the picture plane, or the surface of the painting itself. Our awareness of this surface makes the sense of distance even more telling, as the street curves up and round into the painting. The sense of depth is reinforced by the clouds in the far distance, which form reverse diagonals to those of the rain and echo that of the flagpole. The contrast between light and darkness, from left to right, is a key element in the play of opposites.

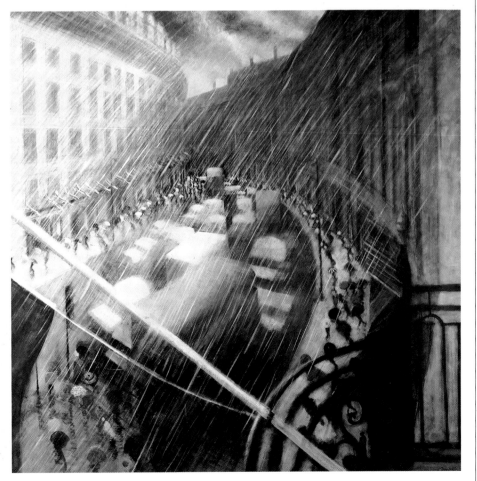

The bright colours of the umbrellas lift them above the cooler tones of the figures, reflections and pavement.

TWO-POINT PERSPECTIVE

TWO-POINT PERSPECTIVE can be drawn up from observed reality, judging angles by eye, as shown in the project that follows (*see* pp. 32-33). A more accurate representation is achieved by the use of plans and projection – a method used by architects. As long as what is being drawn has its base on a flat ground plane and its verticals parallel with the picture plane, the side walls can be at any angle to the picture plane. It can be a four-, five- or eight-sided building, with windows and doors open at any other angle. But whatever the angle, a line drawn from the station point to the picture plane, parallel with any of those sides, will intersect it at a point that establishes the vanishing point for that line and for any other line parallel to it.

Grids and projection

Probably the most common method of putting an image into two-point perspective is by projection from a plan. Heights are established from measure lines on the picture plane, which is where the height is to scale (*below*). But there are other methods, including setting up a perspective grid and relating the heights and widths of the subject to the structure of the grid (*see* pp. 34-35). A combination of such methods can often be employed on the same drawing.

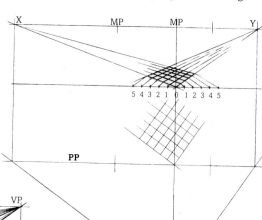

Constructing the pavement (*left*)

Draw lines from the VPs to the point O on the ground line. Take a line from the SP to the left corner of the pavement on the plan. Where this line intersects the PP, project it up vertically to intersect the line drawn from the left VP. These lines cross at the left corner of the pavement in the perspective drawing.

Using measuring points (*above*)

Two arcs drawn through the station point, with each vanishing point (X and Y) as its centre, will give two measuring points at the horizon line. Mark evenly spaced points (1-5) on the ground line. A line from one of the MPs to any of these points will intersect with the line drawn from the vanishing point (O-VP). Draw lines from the points of intersection back to the respective VPs.

Basic projection method (*left*)

Establish the eye-level and where you wish to place the plan in relation to the picture plane. Here, the left-hand corner of the building lies on the picture plane. In the perspective drawing, measure up and mark from the ground line the height that the tower is shown on the elevation. Its intersection with lines from the left vanishing point will provide plotting points for any other towers along that face of the building.

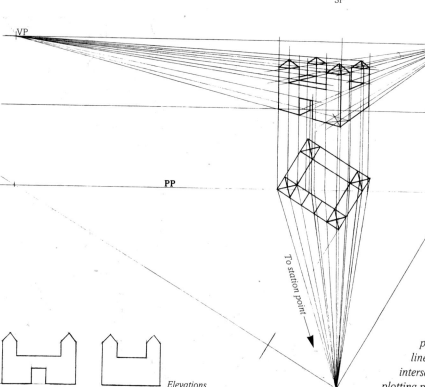

Elevations

Two-point projection method

However complicated the plan or elevation might appear to be, the principle of putting objects into two-point perspective according to the projection method remains the same. Take lines from the station point to the various points on the plan and, where they intersect with the picture plane, project them vertically into the perspective drawing. If part of the plan is behind the picture plane, the lines go back to the picture plane; if part is in front, they go forward to it. Measure lines at the picture plane establish the heights of the various parts of the building in perspective.

Elevations

Elevations are required only for those faces of the building that will be visible in the perspective drawing. Since the position of the vertical lines is established on the plan, it is the height to scale that needs to be measured from the elevations. Such measurements are made on the picture plane and taken back or forwards to the correct position in the perspective drawing.

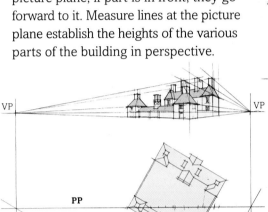

Eye-level

Remember that at the same scale, a change in the distance between the horizon line (eye-level) and the ground line will show a quite different view of your subject. The ground line can be at the same level or below your eye-level. Here, the high horizon gives a view looking down on the building similar to that on the left-hand page. The viewer might be imagined as standing on a hill.

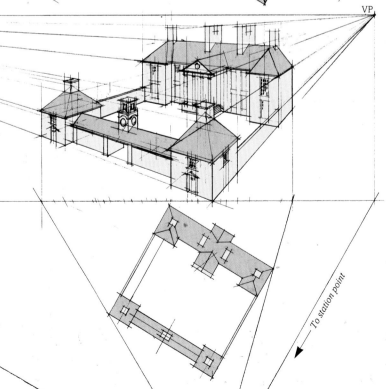

Lower viewpoint

In the drawing above, the plan is in exactly the same position relative to the picture plane as in the drawing on the right. The only difference is the lower eye-level which is closer to that of a viewer standing at ground level. But as the perspective drawing shows, this single difference makes a massive change in the appearance of the building.

Enlargement

In the drawing right, the viewpoint, the eye-level and the angle of the building to the picture plane are the same as in the drawing above it. But the plan of the building has been placed in front of the picture plane rather than partly behind. The effect is to make the perspective image considerably larger.

31

TWO-POINT PAINTING

AN UNDERSTANDING of the basic aspects of two-point perspective construction can help to inform the structure of your painting, so that what you represent looks credible within its setting. This old country house near Venice has windows at different levels and variously shaped chimneys, but the basic shape is a simple rectangle set at around 45 degrees to the picture plane. This is quite simple to draw in perspective and once basic lines are set down, all the additional elements that give the house its character – such as the windows and doors and the rusticated surface of the walls – can be sketched in. You can then concentrate on the painting itself, fleshing out the structure with the tones and colours that give the image its special atmosphere without having to worry about the form of the subject.

1 ▲ Establish the horizon line. Fix the vanishing points and draw the vertical at the front edge of the building. It is now relatively simple to complete the overall shape and to establish the positions of doors and windows on the same plane as the sides of the house.

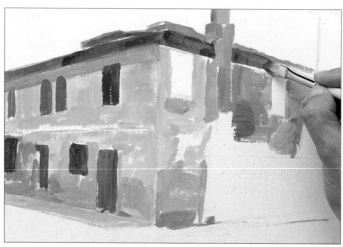

2 ▲ Use the bristle brush to block in the left-hand side of the house using Yellow Ochre, and a mixture of Titanium White and Ultramarine Blue for tones. Let these colours dry before adding the Chromium Oxide Green of the windows on the left and the browns of the doors. Add the shadow under the eaves with Burnt Sienna.

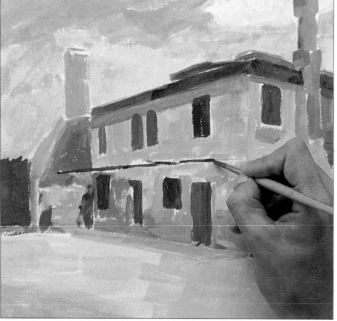

3 ▲ At this point, a strong horizontal line can be painted in across the left-hand side of the house, providing an anchoring feature for the more detailed side of the composition. A dark line of Burnt Sienna will make the porch stand out from the wall. A mixture of Cerulean Blue and Titanium White can be used for the sky.

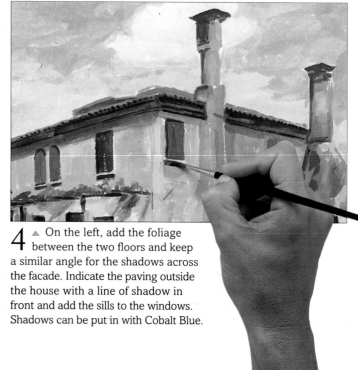

4 ▲ On the left, add the foliage between the two floors and keep a similar angle for the shadows across the facade. Indicate the paving outside the house with a line of shadow in front and add the sills to the windows. Shadows can be put in with Cobalt Blue.

Acrylics

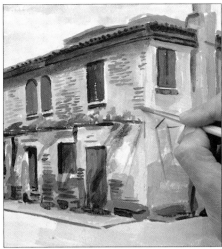

5 ◁ Use the lines of the roof and those at the bottom of the wall to establish the angle of the brickwork, keeping the grapevine as a dividing line. You can create a greyish tone of Burnt Sienna by mixing in Titanium White and Ultramarine Blue. This will distinguish the softer brickwork from the jutting window sills. The corner wall forms a natural barrier between different tones and colours.

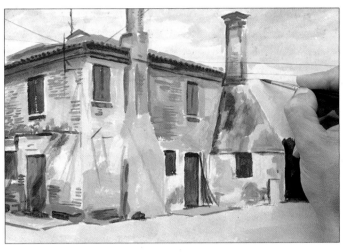

6 ▷ Keep a steady hand and paint in the electricity and telephone wires with Chromium Oxide Green, this extends the composition beyond the house itself while fixing the subject firmly in its context.

7 ▷ The finished painting shows just enough detail to give a complete impression of the house, but not so much that it becomes tight and overworked. The relaxed, loose style of the painting benefits from the accurate underlying structure provided by the initial drawing. It may be bathed in sunlight but with its shutters closed the house invites us to speculate on the identity of its owner. The image remains intriguing.

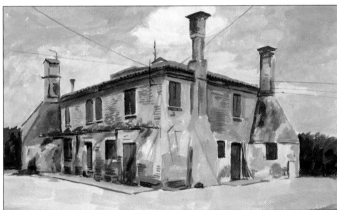

Jane Gifford

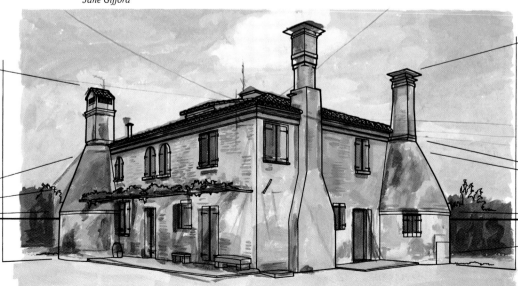

Two-point perspective drawing
A perspective drawing superimposed on the painting shows how closely the two images reflect each other. As painters, we can be intimidated by technical perspective drawings when they appear to be detached from the reality of what we see. But this image shows how far from the truth that is. The sequence illustrates how painting and perspective work together in the process of building up a painting.

Ultramarine Blue

Cobalt Blue

Cerulean Blue

Chromium Oxide Green

Burnt Umber

Burnt Sienna

Cadmium Red

Raw Sienna

Yellow Ochre

Size 4 flat bristle

Size 6 sable

Size 4 sable

33

BOX GRID CONSTRUCTION

ONE OF THE MOST common ways in which artists transfer images from a sketchbook or photograph to a canvas is by putting a grid of squares over the original drawing, putting a grid to the same scale on the canvas and then transferring the image by working from square to square (*see* p. 60). You can use a transparent grid if you have one, or tracing paper.

Of course, this is essentially a two-dimensional exercise. But you can use the same principle in order to put objects into three-dimensional perspective by constructing a perspective box grid. On this page, the construction of a simple one-point perspective box grid is shown; on the right, you can see the stages in the construction of a two-point perspective box grid.

Using the grid

On the ground plane in perspective, you can construct a pavement of squares on a grid and add vertical sides gridded up in the same way and to the same scale. Once the box has been constructed, you can begin to put objects inside it. Their height and width is assessed in relation to the height and width of the grid squares. You may think this is useful only when you are placing rectangular objects within the grid, but in fact you can use it to set up an image of any shape.

Setting up the grid (*right*)

Set up a ground line and a horizon line. Place the centre of vision at an appropriate point on the horizon line. Here, it is a little to the right of a line halfway across the rectangle. Draw a rectangular framework on the picture plane appropriate to the scale of the box you wish to set up. At regular intervals around the edges, mark points where the edges of the squares of the grid, which are at right angles to the picture plane, will intersect with the picture plane. Draw lines from the central vanishing point radiating out through the points marked on the picture plane. This will give you the very basic lines of your grid.

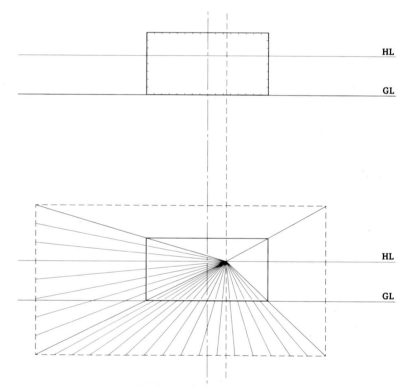

One-point grid

Set up a diagonal vanishing point on the right of the horizon line and draw a line from it through the bottom right-hand corner of the original rectangle. Where this line intersects the orthogonals you can draw the transversals, parallel with the ground line and horizon line. The box can be extended backwards or horizontally as far as is necessary for the construction. Only two sides of the box are shown here, but the grid can of course be extended to the top, the back, the right-hand side and even internally.

Two-point perspective box grid

The following diagrams show the sequence for setting up a perspective box grid in two-point perspective, where the grid is at an angle to the picture plane. Any number of different objects can be placed in the composition using this method. More difficult or irregular shapes, such as curves or circles, can first be put in a square (*see* pp. 22-23) and then placed in the grid and scaled accordingly.

1 ▷ With the grid set at the appropriate angle, set up the station point in relation to the picture plane so that the grid comes within the 60-degree angle of vision.

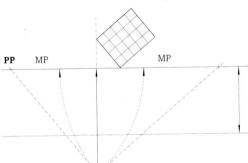

2 ▲ Draw lines from the SP parallel with the sides of the grid to establish VPs for the grid. Mark MPs using the VPs as centres and a radius to the SP.

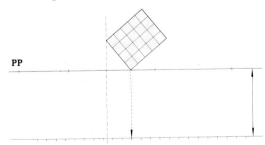

3 ▲ Assuming that you use the line on which you have set up the vanishing and measuring points as the horizon line, set up a ground line on the picture plane an appropriate distance below it and mark the widths of the squares of the grid to scale along this line. The distance between horizon line and ground line will determine the viewpoint of the finished grid.

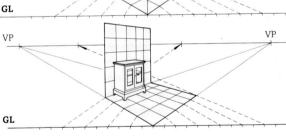

4 ◁ Join the vanishing points to the ground line. Eight squares along, draw a line back to the measuring point.

5 ◁ From the centre, measure ten squares along and draw a line to the measuring point. The intersections of these lines mark the corners of the grid.

6 ◁ Having created the outline of the grid base, you can now draw in the squares of the grid following the same method.

7 ◁ Draw a vertical measure or height line on the picture plane for the vertical face of the box grid.

8 ◁ Take lines back from the height line to the vanishing points. On the vertical faces of the box, establish the positions of the squares.

9 ◁ Once you have established a vertical and a horizontal plane, it is possible for you to start filling the grid with objects to scale.

10 ▷ The positions of the bases of the objects can be determined from a plan and drawn in appropriately in perspective. The heights of objects can be determined in a similar way.

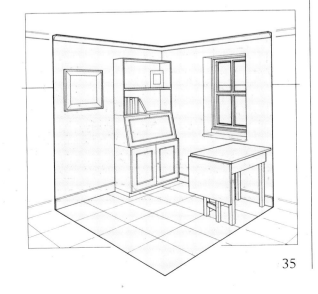

35

INCLINED PLANES

IT IS UNLIKELY that you will always be sketching vertical and horizontal planes on a level surface. Where you have to draw slopes, you can sometimes find the angles by completing the triangle of a vertical height line and a horizontal base line. More often you will need a vanishing point for the slope. Remember that all horizontal lines on a single vertical plane will recede to one vanishing point on the horizon. Any sloping lines on the same plane will recede to vanishing points on a vertical line above or below the vanishing point on the horizon.

THE PRINCIPLES FOR PLOTTING inclined planes can be used as the basis for drawing steps, as shown below. The diagrams on the right show a simple method for accurately plotting the intersection of sloping planes.

1 ▸ If you know the height of the vertical side of a right-angle triangle and the length of its horizontal base line, you can join these to create the third (sloping) side of the triangle. This is a basic step in creating sloping planes in perspective.

2 ▲ Put the vertical and horizontal planes of the triangle into perspective, using measurements on the picture plane and measuring points on the horizon line (see p. 35).

3 ▸ By carrying the lines of the slope in perspective back to their vanishing point, you will see that this point is situated on a vertical line above the vanishing point on the horizon.

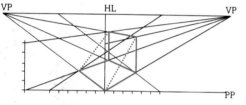

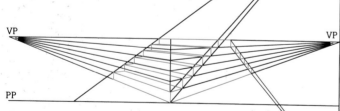

4 ▲ Set up a vertical on the picture plane with the height of steps marked off and take lines from these back to their vanishing points on the horizon. Choose an ascending vanishing point for the angle of the steps and draw lines from this to the top and bottom of the front step. The points where these lines bisect those already drawn show the position of the steps.

1 ▸ Draw the slope of the main roof by running lines back from the vanishing lines to an ascending vanishing point.

2 ▸ By using a separate ascending vanishing point (*left*), draw the gable roof to the left of the main roof. You will now have the two shapes of roof and gable, but not their points of intersection.

3 ▸ From the point X, drop a vertical to bisect the line AB. Join this point to the right VP. Where this cuts the bottom edge of the main roof, draw a line up the main roof using the ascending VP for the main roof until it intersects the point Y. This is the point at which the two sloping planes intersect. A line can now be drawn from this point to the intersection of the two roofs on the horizontal plane below.

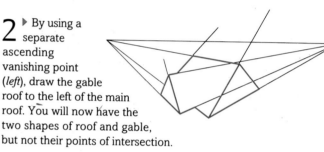

Vanishing point for a set angle

Where you know the angle of a slope (X°), you may want to fix an ascending or descending vanishing point (A). First, establish a measuring point on the horizon line by describing an arc from the station point to the horizon line, using the vanishing point on the horizon line as its centre. A measured angle can be drawn to cut a vertical vanishing line from the vanishing point on the horizon at the ascending vanishing point for that particular angle.

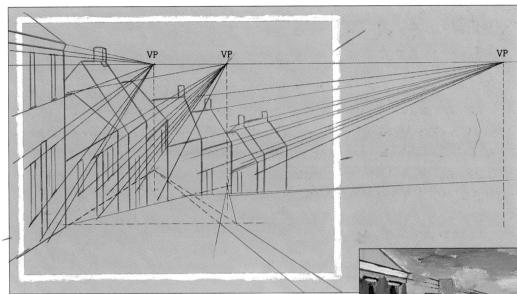

Sloping street

You need to establish the angles of only two receding lines on a building to find the vanishing point on the horizon and from there the vertical axis for the ascending and descending vanishing points. Hold a pencil at arm's length in front of your subject or use tracing paper and a ruler with a photograph.

1 ▲ The vanishing point for the horizontals of windows of a house on sloping ground will be on the horizon line. But if you continue the line where the wall of the house meets the sloping ground, it will extend to a vanishing point immediately below that for the window because window and wall are on the same vertical plane.

2 ▷ As the front walls become more visible to the right, the angles of the cottages in relation to the picture plane change. Hence the vanishing point for horizontal features, such as the windows, doors and roof line, moves right along the horizon line. The descending vanishing points also change with the angle of the cottages, but remain on a vertical axis below each of the vanishing points on the horizon.

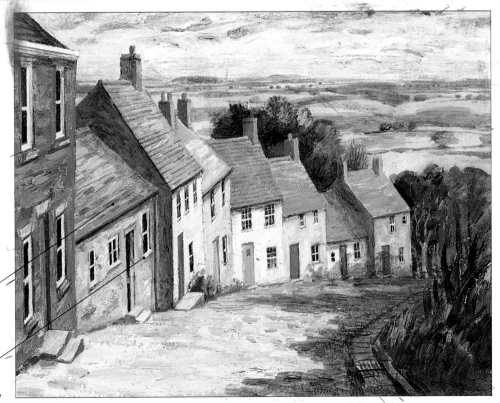

View from a hill

The solid perspective structure underlying the oil painting gives strength to the image and, together with the warm orange-browns and ochres of the buildings, leads the eye from the near foreground through to the cooler greens and blues of the far distance. The strong sunlight and deep shadows emphasize the structure and tone of the trees on the right. They serve compositionally to prevent the row of cottages from sliding off the right-hand side of the painting.

The texture of the rough oil brush-strokes used here conveys the layered structure of the clay roof tiling.

Details on the houses are put in with single strokes of thin colour, following the basic perspective structure.

Noel McCready

PLANS & ELEVATIONS

BY USING THE PROJECTION METHOD, simple plans and elevations can be turned into complex two-point perspective compositions. The setting-up stages establish the angle of view required and its size. Subsequent stages involve transferring the points of intersection with the picture plane from a plan to a separate perspective drawing. Keeping the perspective drawing separate from the plan enables you to draw it directly onto your painting surface.

Elevations

Plan

1 ◀ Though it relates to a particular style of architecture, this clapboard house exists only in the mind of the artist who drew it. It is not always necessary to rely on things we see. We can invent hypothetical plans and elevations and incorporate them as 3-D images into our paintings.

2 ▶ First, you need to decide from which angle you wish to view the building. From the three angles of 60 degrees shown here, the central one would be too two-dimensional and the one on the right, though similar to that on the left, would present a less interesting view of the verandah.

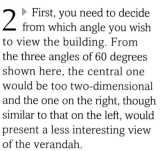
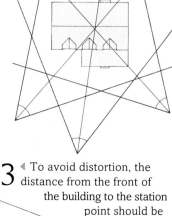

3 ◀ To avoid distortion, the distance from the front of the building to the station point should be one and a half to three times the height of the building.

Behind the picture plane

The position of the plan relative to the picture plane will determine the size of the image. In the drawing on the left, the house has been positioned behind the picture plane, with its front corner touching it. Lines are projected from the plan to the picture plane via each side of the house as shown. The width of the house as it would appear on the perspective drawing is shown between the two arrows.

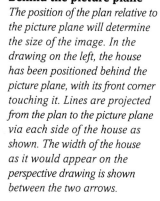

PP

SP

In front of the picture plane

In the drawing on the right, an alternative positioning of the plan is suggested from that drawn up on the rest of these pages. The house is positioned so that most of the building stands forward of the picture plane. Constructed to the same scale, this drawing would produce a larger house than the finished drawing on the opposite page.

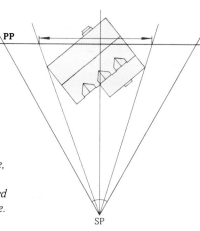

PP

SP

4 ▶ Placing the house behind the picture plane, you will need to establish two vanishing points for the sides of the building. Draw lines back from the station point parallel with the sides of the building. These will cut the picture plane on each side of the building at the vanishing points.

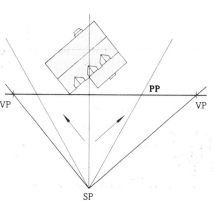

PP

VP VP

SP

5 ▶ The position of the verticals of the building on the perspective drawing is determined by running lines from the station point to principal points on the plan (the corners of the building, the position of windows, etc.). You should mark the intersection of these lines with the picture plane.

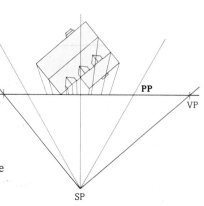

PP

VP VP

SP

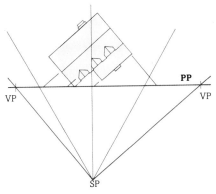

6 ▲ To establish the height of different points on the building, height lines will be drawn onto the picture plane. Mark the position of these height lines by extending lines from the principal axes of the building to touch the picture plane at the appropriate position.

7 ▷ You will have marked the vanishing points and all the principal points where the vertical lines of the building and the height lines intersect with the picture plane. Now transfer these to a piece of paper as shown, so that when you set up the perspective drawing you do not need to draw the plan as well.

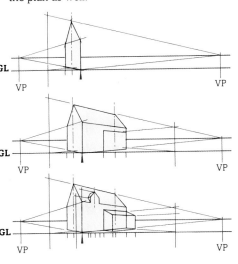

High viewpoint

A high viewpoint can give an interesting aerial view and can be particularly useful in an overview of several blocks, but the building itself may look less imposing.

Middle viewpoint

To start the perspective drawing, you need to draw only the ground line and the horizon line. Here, the horizon line lies across the eaves of the house, which may be confusing.

Low viewpoint

This is a more human view in that the distance between the horizon line and the ground line is equivalent to the height of a human being drawn in scale.

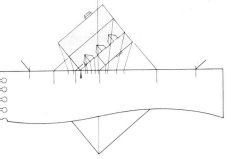

9 ◁ Establish height lines and the edges of the building by raising verticals from points on the ground line.

10 ◁ Draw lines from points on the height lines back to the relevant vanishing points to show the horizontal lines of the building.

11 ◁ Gradually build up details by working in a similar way from points on the ground line.

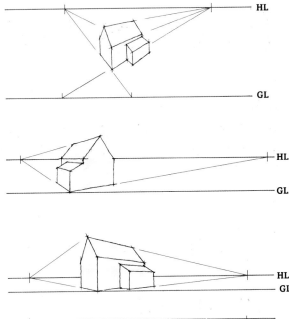

8 ▲ Transfer the reference points from the piece of paper to the ground line in the perspective drawing. These are the corresponding points on the picture plane for different elements in the composition and will be the points from which you draw up your verticals.

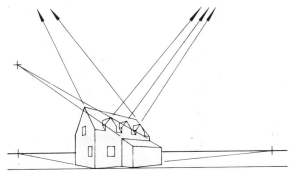

12 ▲ The vanishing points for the sloping planes of the roofs can be found on a vertical axis from each of the vanishing points on the horizon. But it is not necessary to use these here, since the slopes can be drawn by completing the third side of a triangle.

13 ◁ The finished drawing emerges with all its detail complete. Any element can be measured from the picture plane, taken back into the drawing and then worked up.

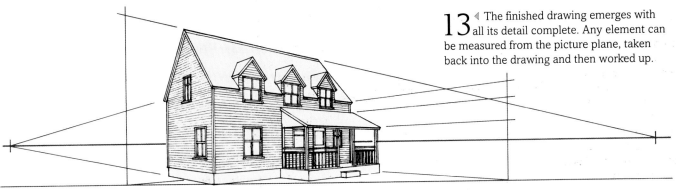

THREE-POINT PERSPECTIVE

WHEN WE TAKE photographs of buildings from close-to, we see that the vertical sides of the buildings seem to lean in towards the middle of the picture from the vertical edge of the photograph. This is because they are subject to the laws of perspective like any other plane receding from our view. The addition of a third vanishing point in the vertical plane takes account of the convergence in the vertical sides of a tall building as well as that on the horizontal plane. It comes into play when we are looking up at a building or conversely looking down on a scene – in other words, when the picture plane is tipped, or at an angle to the vertical.

Three-point projection

Three-point projection for plans and elevations is more complex than that for one- or two-point perspective. It can involve the incorporation of an inclined picture plane set at the correct angle to the ground plane. Some methods require a special plan of the object as seen from the inclined angle. This is prepared by projection from a tilted elevation.

Worm's-eye view

In this drawing, the three-point perspective is purposely exaggerated. The height of the buildings and the insignificant scale of the viewer are emphasized by placing the high vanishing point lower than it might be. The dramatic effect is like powerful uplighting along the vertical lines of the buildings.

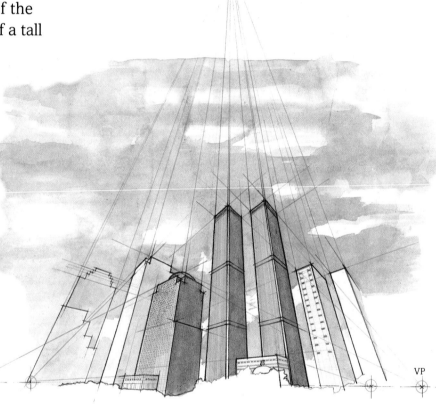

Bird's-eye view

In the reverse of the drawing above, great plunging perspectives are produced by adopting a similarly dramatic viewpoint, but, in this case, looking down. So here the vertical vanishing point is located at the bottom of the drawing. An aerial view like this is considerably more common in the twentieth century and we are now quite accustomed to seeing such images taken from helicopters and aeroplanes. But there is also a particular feel to this kind of perspective that links it to the great romantic landscapes of the early decades of the nineteenth century (see p. 11). Generally, such steep views are too dramatic for any but the most imposing of compositions. It is a quality which has been picked up in film and animation rather than in painting. In spite of this, some elements of three-point perspective are required in all but the simplest constructions and it is therefore wise to consider this when establishing the basic structure of your composition.

Mountain landscape

As with any style of perspective drawing, the three-point system gives a particular appearance to an image. Artists use the system when looking down on a subject in order to draw the eye right into the centre of the composition. When looking up, it creates an awesome sense of scale. This view of an imaginary landscape seen from a cliff-top gives a sense of the whole scene opening out from a central core, like the petals of a flower. The effect is exaggerated by a vertical vanishing point that manages to stay within the borders of the composition. The images here show how three-point perspective can be adapted to suit the requirements of the artist's composition.

1 ▷ The three vanishing points can be set at the extremities of the composition, with the two horizontal vanishing points at the top on the horizon line and the vertical vanishing point at the bottom in the middle. The construction of the relatively simple village buildings is straightforward, using the intersections of lines from all three vanishing points to form the basis of the structures.

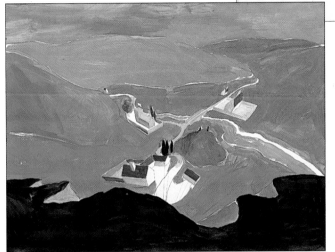

2 ◁ Block in the main areas of tone and colour with an opaque acrylic. This creates an underpainting on which to build up form and colour. Note the depth of tone used in the foreground. This acts to separate it from the distant view. Planes and levels are distinguished by different base colours. The warm and cool red roofs of the buildings are set up in complementary contrast to the blues and greens of the landscape.

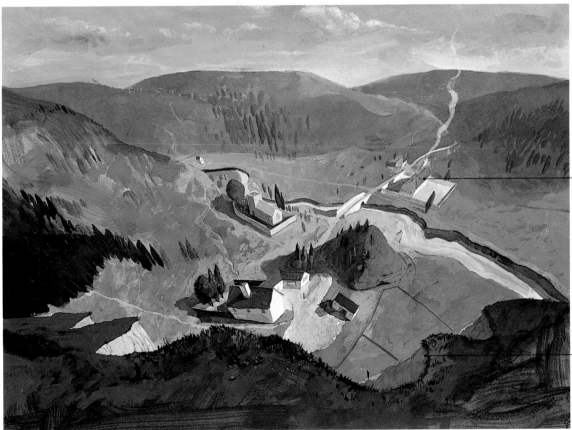

The buildings are painted in at angles to the vertical and appear to lean out of the centre of the painting.

The vertiginous viewpoint of the artist is conveyed by the depiction of the cliff faces, which run at diagonals to the ground line.

Finished composition

During the subsequent stages of painting, the texture of the landscape itself is enriched and more detail is applied to the buildings. The angle and direction of light over the landscape is established, with shadows cast from the walls, trees and buildings. Where the distant hills are in shadow, they are deepened in tone: the total effect is to make the viewer focus on the circular sunlit area at the centre of the composition.

Julian Bray

THREE-POINT PAINTING

WHEN YOU LOOK UP AT a very tall building, or when you are standing so close to a smaller building that you have to look up to take it in, the effect of vertical convergence is considerably accentuated. Here, the artist has used a photographic reference, but at such a close range he has been unable to fit the subject in one shot and so has made a montage of four shots to provide information for a three-point perspective pencil sketch. The paradox with three-point perspective is that on the paper or canvas, the effect of the subject receding into the sky away from the viewer generates a sense of distance from the image. In reality, the viewer is particularly aware of the proximity of the building.

A montage of the photographs used for reference. The different lighting in each photograph is noticeable

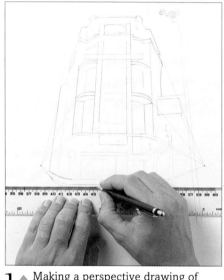

1 ▲ Making a perspective drawing of the image with a ruler and pencil creates a clear structure and a clean image on which to build up the acrylic washes.

Vanishing points
The two horizontal vanishing points are relatively close together on this narrow building. But the vertical vanishing point is far above the edge of the paper.

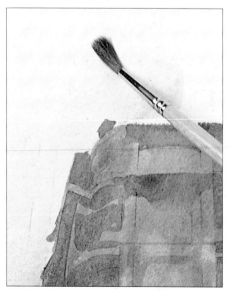

2 ◀ A pale wash of Payne's Gray and Phthalo Blue around the top of the building gives an indication of the sky and lessens the stark contrast with the white of the paper, creating a sense of depth.

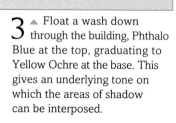

3 ▲ Float a wash down through the building, Phthalo Blue at the top, graduating to Yellow Ochre at the base. This gives an underlying tone on which the areas of shadow can be interposed.

Working tonally

By using very watery acrylic washes you can mimic the effects of watercolour. Recesses fall back as heavier tones are put in, while unpainted or lightly painted areas shine through, pulling these elements forward.

Faint washes of Burnt Sienna and Phthalo Blue bring the edges of the building forward.

Throughout this early stage the brush is kept very wet and colours remain largely unmixed.

Acrylics

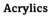

Deep Brilliant Red

Raw Sienna

Yellow Ochre

Payne's Gray

Olive Green

Phthalo Blue

Cerulean Blue

French Ultramarine

4 ▲ Use the point of the brush to paint a thin border of Raw Sienna around the street sign on the lamppost, in order to give it definition and bring it to the front of the composition.

5 ▷ The cool crimson red band of the sign is unmixed with other colours and works well as a bridge between the blue above it and the blue-grey underneath.

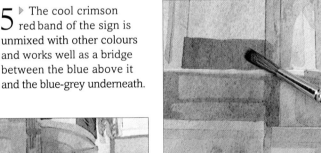

6 ◁ Build up detail in the shop-front by adding further defined areas of wash. Although tones are dark in this area, their strength and subtlety arises from a build-up of thin washes rather than mixing a single dark tone.

7 ▷ Indicate the buildings to the right of the lamppost with firm vertical strokes of a flat bristle brush in a wash of Phthalo Blue. Use a mix of Titanium White and Phthalo Blue to paint in the sky.

8 ▷ Give the sky some body by using well-diluted Titanium White with a flat bristle brush. Do not worry about rendering clouds or sky accurately, if you keep the brush sufficiently wet, loose washes will bleed into one another, giving a convincing result. Allow the edge of the building and the lamppost to dry before applying the subsequent washes for the sky.

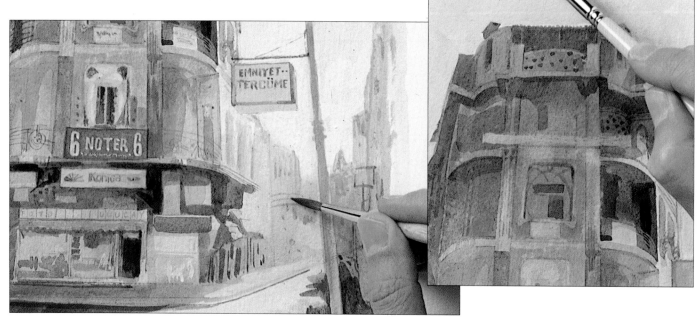

9 ▲ Define the forms of the distant buildings with a pale wash of Phthalo Blue. Details of the buildings on the right can be painted in with Burnt Sienna. Colours here must be painted subtly, as paler washes will give a sense of distance. You should paint the more distant elements on this plane quite loosely, for the viewer's perception of the architecture will lose detail as it recedes.

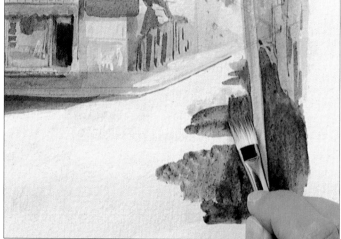

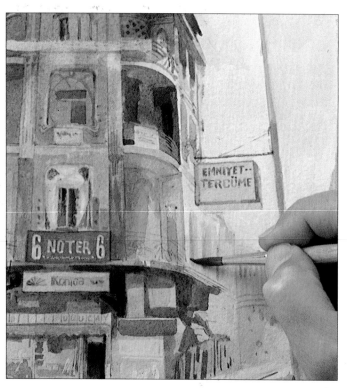

10 ◁ Try to establish a sense of perspective in the progressive diminution of detail, from the part of the building closest to the viewer to that which is farthest away. The nearer side of the windows can be painted in Raw Sienna, while the overall outline of the frame can be rendered in a paler wash of the same colour. Architectural elements such as windows and doors are ideal for conveying a sense of recession and depth. Many of these features can be suggested with a single stroke.

11 ▲ Having established where the sun is in relation to the subject (here it comes from the right), paint the shadows of the buildings on the right of the picture with the bristle brush using bold strokes of Burnt Sienna. Paint carefully around the lamppost in order to keep its pale shape against the brown background shadow. The foreground can be painted in with a wash of Yellow Ochre followed by a wash of Titanium White, the latter to convey the street's glaring white light.

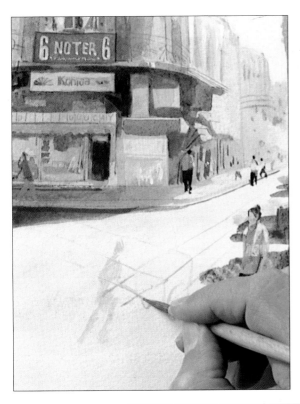

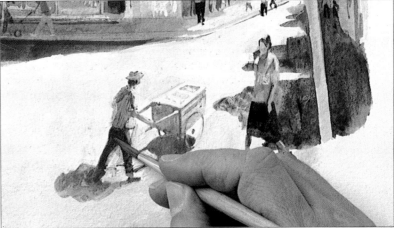

12 ◀ With the point of the soft sable brush and using a thin mix of Cerulean Blue and Titanium White, sketch in the broad outlines of the man wheeling the cart. Use the vanishing points established for the horizontal lines of the building to work out the perspective of the cart. These faint lines can later be painted over.

13 ▲ The two foreground figures lead our eye into the space of the painting. Paint them in sufficient detail for them to be credible but do not overwork them. The painting needs to have an overall consistency of style. The shadows of man and cart have been painted in Burnt Sienna mixed with the white and yellow ground.

Corner building in Istanbul

The finished painting retains a fresh looseness of style with enough detail to establish a real sense of place. The perspective works well in the horizontal plane, where the man wheeling the cart leads the eye directly to the figures walking towards the vanishing point on the right-hand side of the image. There is a fine sense of space and light here. But it also works well in the vertical plane with the eye being led up the painting by the converging vertical sides of the building and then back down to the ground plane via the lamppost.

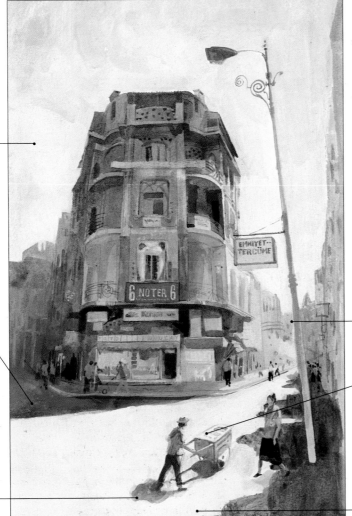

A mixture of Titanium White and Ultramarine Blue has been used to paint in the rest of the sky.

The two sides of the painting form an energetic interplay of light and shade.

The shadow of the man and cart, placed securely in the centre of the large expanse of white road, provides a solid link with the ground plane.

Julian Bray

Apparently towering above the building itself, the lamppost indicates that the plane of the artist's viewpoint is tilted.

The angle of the cart draws the eye up to the street on the right.

The artist has felt confident to reinterpret his source. The car and some of the figures have been dropped to give the building greater prominence.

Materials

Clutch pencil, 0.5 lead

Size 6 sable

Size 4 short flat bristle

45

GALLERY OF LANDSCAPE & ARCHITECTURE

IN THE DEPICTION of both landscape and architecture, an interesting viewpoint will change the whole nature of the composition. The tilted picture plane of Michael Smith's painting leads the eye up to the vertical convergence in the architecture, while the tilted-down picture plane of the Sydney Carline painting brings the horizon line close to the top edge of the image. All the images share a preoccupation with the depiction of space, whether in the panoramic exterior of David Prentice's work or the atmospheric interior of the Johnson painting. The latter is a beautiful example of two-point angular perspective.

Michael Smith, *Expo '92,* *1.22 x 1.83 m (4 x 6 ft)*
The vast awning that sweeps across this composition conveys a strong sense of space and atmosphere. It both transmits and reflects the bright Mediterranean light of Seville and emphasizes the low horizon, allowing us to focus on a skyline of plunging perspectives. An illusion of depth is created, an effect echoed in the cool grey and blue tones of the oil paint.

Sydney Carline, *The Destruction of an Austrian Machine in the Gorge of the Brenta Valley, Italy, 1918,* *76.2 x 91.4 cm (30 x 36 in)*
An important component in our understanding of perspective is the artist's ability to define space. Here, Carline articulates the volume of space within and above the landscape by the aeroplanes that circle around each other in the spaces between the distant landforms.

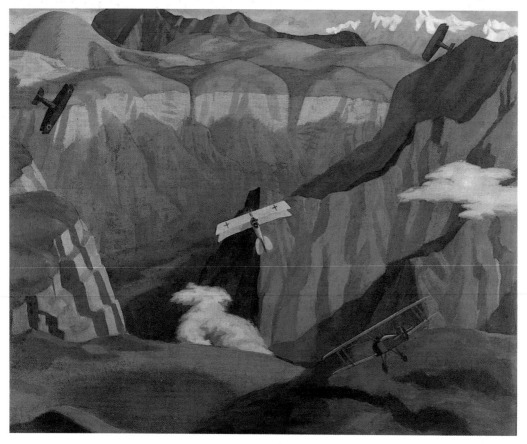

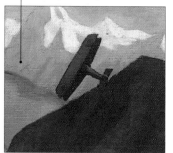

A sense of depth is created by painting the planes against contrasting grounds.

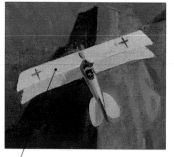

The peace of the scene is about to be shattered as the white plane is circled by its three red opponents.

Ben Johnson, *The Unattended Moment,* *1.84 x 2.43 m (6 ft x 7 ft 11 in)*
Johnson is outstanding among contemporary painters in his ability to create atmosphere and meaning within images of uninhabited architectural spaces. He uses complex preliminary work on a computer and photo- *chemical methods to transcribe the perspective onto canvas. Here, the surface of the pool is flat, mirror-like and undisturbed by any hint of moving air. It is as if time has been suspended: the light takes on a living dimension, filling voids, caressing surfaces and inviting contemplation.*

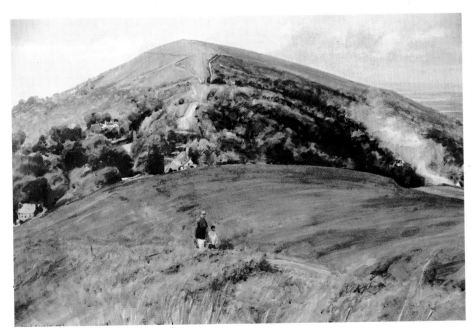

David Prentice, *Woman and Child, Worcester Beacon, Malvern,*
56 x 84 cm (22 x 33 in)
In a landscape painting, it can be difficult to establish the kind of scale needed to give the viewer a real sense of the breadth or enormity of the subject depicted. Here, the artist has judiciously placed the path in perspective, winding down the hill in the distance, giving a sense of the journey of the two foreground figures. Combined with the scale of the buildings, this draws us into the painting and provides a measure by which the size of the hill may be judged. In the far distance beyond the hill, the flat landscape continues in progressively cooler tones to the horizon.

REFLECTIONS

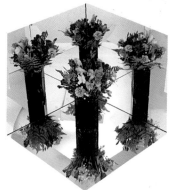

T HE INCLUSION OF SOME FORM OF REFLECTION in your painting can add a further dimension. The angle of the reflected image to the reflective surface will be the same as that of the object itself. In plan, you can see that the distance from any point on the image to the reflective surface is equal to the distance from the same point in the reflection to the reflective surface. This is true of reflections both in glass and in water.

ABOVE, A VASE of flowers is placed on a horizontal mirror with vertical mirrors at 90 degrees. A ray of light from a corner of the vase, travelling on a line parallel to the picture plane to the mirror on the right, strikes the mirror at an angle of 45 degrees and is reflected at the same angle (*see* right).

Deceptive mirrors
You might think that the front faces of all the vases are the same, but in fact the front face of the right-hand vase is the (concealed) side face of the central (actual) vase. Similarly the front of the left-hand vase is the left side of the actual vase.

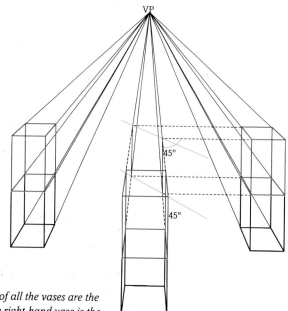

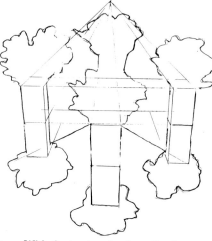

1 ▲ With the basic rules for reflections in mind, it is easier to understand the construction of an image and to sketch the preliminary structure for a painting. Keep pencil lines light so they can be erased later.

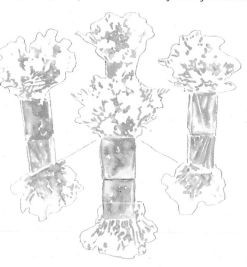

2 ▲ For the main areas of shadow within the broad pencil outlines, mix a single colour and, with a soft hair brush, apply thin washes to serve as the underpainting.

3 ▶ Build up the tones and colours using thin washes. In order to keep the colours clean, ensure that the foliage is dry before painting in the flowers.

WHEN YOU ARE OUT sketching, you are more likely to come across reflections in water that are broken up, with the surface disturbed by waves or wind, than to find clear, undisturbed reflections on completely smooth water. A reflection on disturbed water shows a fragmented image. The surface still acts like a mirror, so the angle of incidence equals the angle of reflection. As the water is disturbed, it reflects in many directions according to the angle of its surface. This can be seen in the diagram (*right*), where the viewer sees the sky reflected from one part of the wave and the building from another.

RIPPLE EFFECT

The uneven surface of rippled water creates a fragmented image. This is caused by the water reflecting different angles of the surrounding area. Here, the peak of the ripple reflects the side of the building while the trough reflects the sky, creating a striped effect on the water. Again, the angle of incidence (a or b) equals the angle of reflection (A or B).

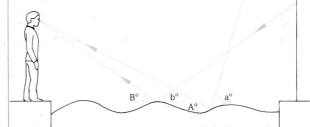

Canal view, Venice (*left*)

In this characteristic view of a Venetian canal, the artist has used a watery acrylic wash to mimic the effects of watercolour. In order to create the ragged horizontal ripples, the brush is kept quite wet, as in watercolour technique, allowing the colour to follow its natural course, giving the painting a relaxed, spontaneous feel. You can consider the perspective structure underlying the image as continuing within the reflection as if nothing on the surface of the water is affecting it. Then adapt the surface according to the nature of the ripples. Bear in mind that in Venice the movement of the water is often reflected on the sides of the buildings themselves.

Photo reference (*below left*)

The buildings are seen from an oblique angle. This has the effect of accentuating the verticals of the edges, windows and doors of the buildings. The verticals are counterpointed by the ripples in the water, which give a horizontal look to the reflections.

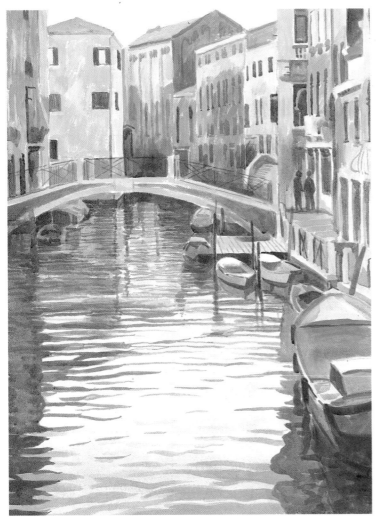

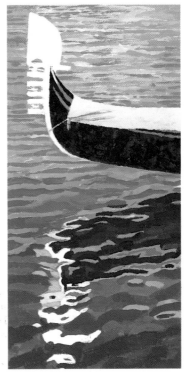

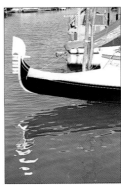

Gondola in open water (*far right*)

On a smooth surface, the height of the gondola from the surface of the water would be reflected to an equivalent depth. The prow of the boat is raised well above the level of the water, so you would need to measure horizontally along from where the boat actually touches the water towards the end of the prow and intersect with a vertical dropped from the prow. This vertical distance would need to be doubled to establish the depth of the prow in reflection. The water is undulating and the edges of the reflection are fluid.

Gondola at quayside (*right*)

The boats surrounding the gondola shown here have been omitted from the painting (far right). *The use of thick acrylic in the painting was suggested by the circles of reflected light in the photograph and mimic the effects of oil.*

SUNLIGHT & SHADOWS

FOR THE PURPOSES of perspective, we assume that the sun's rays are parallel, since the light source is so far away. When dealing with shadows cast by the sun, you must first establish whether the sun is in front of you, behind or at the side. If at the side, to establish the length of the shadow, you follow the angle of the sun's rays through the top or corners of the object to the ground. This is the case whether the sun is to the left or right, and whatever its angle to the vertical. When the sun is in front, shadows appear to widen as they get closer to you. When it is behind you, shadows appear to get smaller as they recede. In the latter two cases, establish the vanishing point for the sun's rays and the vanishing point for the sun's shadows. These are always on the same axis.

Achieving three-dimensions with light and shade

It is important to establish the direction of the light in order to understand how and where shadows are cast. On plans and elevations, architects often project rays of light at 45 degrees to the horizontal from top left to bottom right in elevation, and from bottom left to top right in plan.

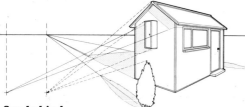

Sun behind

The vanishing point for the shadows lies on the horizon on a vertical line directly above the vanishing point for the sun's parallel rays, which appear to converge.

Sun to the side

When the sun is at the side, assess the angle of its rays and draw parallel lines from the topmost points of the objects to the ground plane, where the lengths of the shadows can be set. A pencil held at arm's length can easily establish the angle.

Sun in front

When the sun is up in front of you, the vanishing point for the sun's rays (the sun itself) is always above the horizon. The vanishing point for the sun's shadows cast on a horizontal ground plane is on the horizon line on a vertical below the vanishing point for the sun's rays.

Study in natural light

The sun is in front of the viewer around 30 degrees to the left and low in the sky, so it casts long shadows. The vanishing point for the shadows is just to the left of the top left corner of the image so the vanishing lines of the shadows all converge to that point.

Pencil study

In this vigorous pencil study, the artist explores the effects of light and shade monochromatically. The expressive tonal shading identifies areas in shadow and gives them depth and weight, making them almost as tangible as the chairs, table and shrubs. By contrast, it also emphasizes the brightness of the sunlit areas.

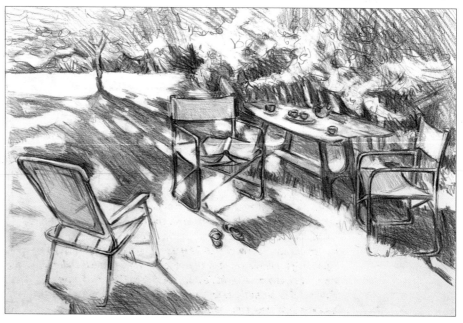

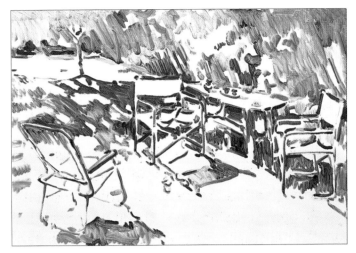

1 ◁ In a painting that concentrates, as this does, on the effects of light and shade, it makes sense to define roughly the areas in shadow at a preliminary stage using a single colour. As the sunlit areas will be predominantly yellow, underpaint the shadows in blue. This makes for a good colour contrast. It also allows you to concentrate on getting the form and tone right before focusing on colour. It is tempting not to do any more to a painting at this stage where all the main components of the image have been established with economy and fluent brushwork.

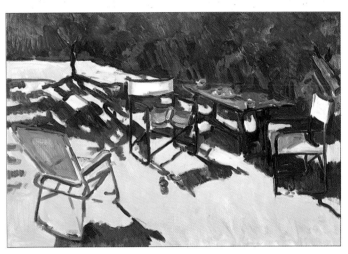

2 ▷ Flood the foreground with light by loosely painting in an overall warm yellow. This colour is complemented by the various tones of purple in the table, the shrubbery and the trunk of the tree. The depth of tone in the shadows is increased by the addition of a deep, cool green. This emphasizes the idea of the light establishing a pattern, which is every bit as important as the objects. The thin red lines of the tubular steel chairs are set up as a contrast to the green foliage, while the pale shadows on the canvas seats and seat backs can be sketched in using pale lilac.

Tea in the Garden

By careful reworking, the image moves from a diagrammatic-looking underpainting, where the tonal contrasts remain harsh, to a more fully resolved work with a richer, softer look. With the addition of sunlit foliage above the table and the softening and blending at the junction between sunlit areas and areas of shadow on the ground, the painting now has a more inviting atmosphere. It retains a relaxed spontaneity, held together by a strong perspective structure.

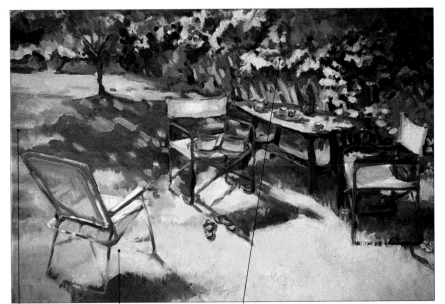

The cool lilac shadow on the seat complements the warmer yellow colours.

Sue Sareen

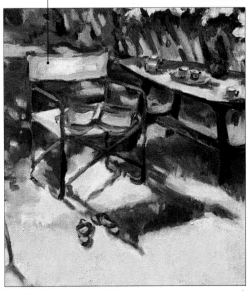

Towards the left edge, the yellows become more orange-red, thus helping to frame the image.

The tubular structure of the chair produces strong areas of negative space.

The sunlight on the table and on the foliage above lifts the light off the single plane of the ground, creating a sense of space between the table and grass.

Achieving three dimensions

When painting or drawing outside, being aware of the position of the sun as outlined above will enable you to achieve an overall consistency in the orientation of shadows, thus giving your painting real credibility. Above all, it is the effects of light and shade that give a painting the illusion of three dimensions. Bear in mind that there may not always be a bright light source such as the sun on a clear day and that when the weather is overcast the effects described here are much more muted and the tonal contrast more subtle.

ARTIFICIAL LIGHT

T HE PERSPECTIVE OF SHADOWS cast from a single light source, such as a candle, is relatively straightforward. Light radiates in all directions from the source and the shadows cast by objects placed all around the light source converge at a vanishing point directly below that light source on the ground plane. (The ground plane is the vanishing point for shadows.) You can establish the length of the shadows by projecting lines from the light source itself via the top of the object to the ground plane. For an image that needs to express a warm intimate scene, such as this still life, pastel on warm orange-brown paper is a good choice of medium. Although the image is effectively tonal, the use of adjacent warm colour harmonies fill it with life.

Preparatory studies
Make a few preliminary studies of parts of the composition before tackling the image as a whole.

1 ▲ Draw in the shapes of the objects using a single colour. From this close position, with a wide angle of view, the vertical objects at the edges, such as the bottle, appear to lean outwards. Sketch in a guide to the edges of the shadows like the spokes of a wheel.

ARTIFICIAL LIGHT

Unlike natural daylight, in the case of artificial light the light source is smaller than the subject, and will cast shadows that flare from the base of the source. This is because the light source is smaller than the object that casts the shadow.

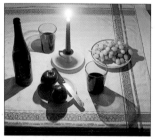

Test the truth of these rules with your own still life. In setting it up, try to create a composition and a viewpoint that gives its component parts clarity, allowing you to see clearly what is going on.

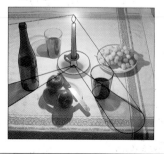

The edges of the shadows can be determined by lines taken from the light source past the top of the object to the ground plane. The vanishing point for the shadows is at the base of the candle.

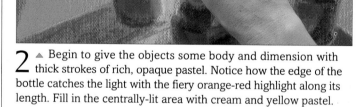

2 ▲ Begin to give the objects some body and dimension with thick strokes of rich, opaque pastel. Notice how the edge of the bottle catches the light with the fiery orange-red highlight along its length. Fill in the centrally-lit area with cream and yellow pastel.

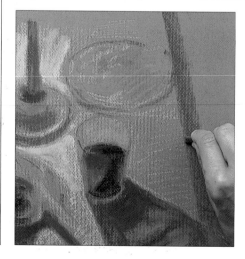

3 ◀ Draw the shape of the reflection in the wine glass and establish the tonal contrast between the cool dark brown and the warm bright red. Sketch in the edge of the cloth to act as a perspective framing device for the image. The red streak of the candle also contrasts well with the bright-toned central area of the tablecloth.

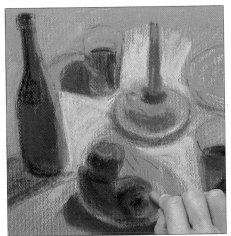

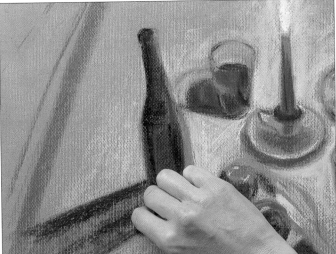

5 ◀ Deepen and extend the shadows on the bottle edge and to the shadow on the table using the dark brown pastel. With the same pastel give definition to the rim of the glass, its shadow and base. Similarly, heighten the contrast in the tones of the candle-holder and candle and add highlights with light yellow.

4 ▲ Build up the shapes of the apples with broad tonal areas. Use the deepest brown for the base and bottom edges and for the indented top. The edges are drawn in with a warm rich red similar to that used for the bottle and glasses. Be careful to avoid scuffing with your hand the colours you have already applied, especially in the highlighted areas.

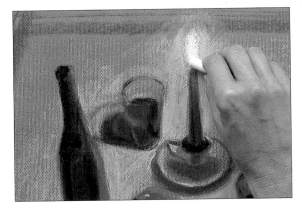

6 ◀ Re-establish the pure white of the candle flame. This is the brightest area and a point of focus for the viewer; it contains the image and holds it together. Notice how the lighter yellows in the centre are modified by the addition of this bright tone.

7 ▲ Add black to the edges of the glasses and bottle and retouch the white highlights. You should save the brightest and darkest tones to the end. This is especially true of pastel, where the blending of colours during drawing may neutralize tonal contrasts.

Still life with candle
The finished drawing has a charm and lack of pretension that makes it very accessible. The texture of the pastel on the paper is very evident and adds to the work's character.

When looking at an image you can half-close your eyes to judge if the variation in tones is credible.

A streak of lighter tone in the shadow of the bottle gives a sense of the container's transparency.

A rather cold, crisp photograph has been transformed into a warmer image by the choice of medium and colour.

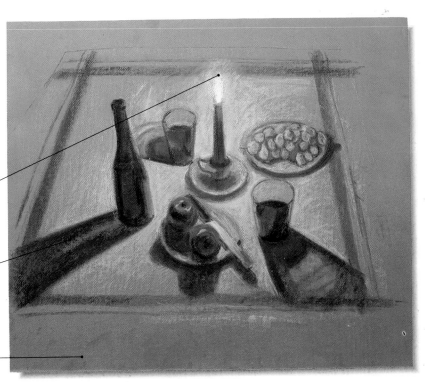

Pastels

Jane Gifford

GALLERY OF REFLECTIONS & SHADOWS

THE ACCURATE depiction of shadows gives credibility to the three-dimensional forms that we are painting and locates them within a particular space. The correct projection of shadows is therefore a crucial component in perspective. The nature and position of the light source illuminating our subject and the nature of the surface on which the light falls will determine how the light is perceived.

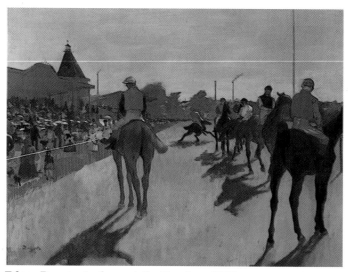

Edgar Degas, *Jockeys at the Stands,* **c.1866,** *46 x 61 cm (18 x 24 in)*
This painting shows how accurate shadows can define a setting and the nature of the surface on which they fall. The shadows on the track recede to a vanishing point on the horizon line immediately below the sun.

Ian Cook, *Mission House, Georgia,* *61 x 51 cm (24 x 20 in)*
Strong tonal contrasts and the use of complementary colours in this painting give a clearly three-dimensional image of the chapel and trees. The artist has also incorporated warm and cool shadows: the warm orange hues of the field contrast with the blue shadows of the chapel. The long shadow cast by the spire suggests that it is either early morning or late afternooon.

In this detail, rich, overhanging foliage bends heavily towards the water. The boughs are thick with paint as if to emphasize the textural contrast with the smooth, still water.

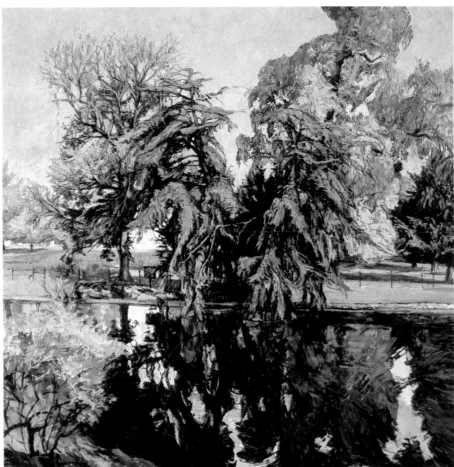

Ben Levene RA, *Reverse Mirror Image with Japanese Vase,* 86 x 97 cm (34 x 38 in)
Setting up a mirror behind a subject, as Levene has done here, opens out the space, deepens the background and allows the artist to give an all-round view of the objects being depicted. This is apparent in the angle of the human figures reflected from the vase. The effect gives the painting a certain decorousness, as if the objects are politely taking their partners in a rather formal dance.

William Bowyer RA, *The Golden Tree,* 1.22 x 1.22 m (48 x 48 in)
On still water, reflections are easy to work out. When a tree is set back from the water's edge, as here, you should imagine the level water continuing through the bank to the point at which it would meet the tree trunk if the bank were not there. You measure up to the top of the tree from that point and then mark the same distance down for the extent of the reflection.

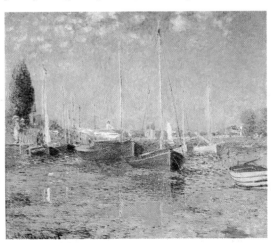

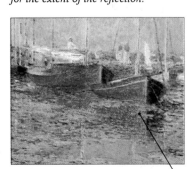

In contrast to the William Bowyer painting above, here the surface of the water is disturbed. The reflection is broken up into a myriad of tiny mirrors at different angles that reflect different colours – greens, blues and yellows – according to the slope of the ripples.

Claude Monet, *The Red Boats,* c.1875,
55 x 65 cm (21½ x 25½ in)
Here, the bright lines of the masts extend, by reflection, into the water, providing a vertical structure for the horizontal dashes of colour.

MODERN DEVICES

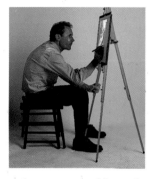

Any movement of the easel when using a projector will put the image out of alignment.

OVER THE CENTURIES there has been a wide range of devices to enable artists to draw images in perspective. These have included simple drawing frames and finders, including those with grids in wire, nylon or thread. These remain useful tools when trying to get the perspective right on location. Other helpful devices include the reducing glass. This looks like a magnifying glass, but gives a miniature image of the scene seen through it. The camera obscura and the camera lucida (*see* p. 70) were used in the past to project the image of a scene onto the canvas. They have now largely been replaced by the slide projector. Artists often take photographic slides of subjects that they want to paint and use these for reference.

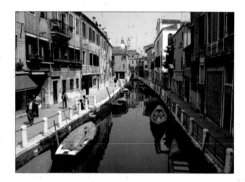

1 ◀ The standard lens in cheap cameras is a relatively wide-angle one that does not allow you to zoom in as your eye can. For reference purposes, use a camera with a lens of variable focal length, from 28mm (wide-angle) to 260mm (telephoto), for example. This allows you to focus on whichever part of the scene you wish to include.

2 ▶ You will have to get used to working in subdued lighting in order to draw out an image using the slide projector. You need enough ambient light to allow you to see what your pencil or charcoal is doing on the canvas, but not so much that you cannot see the projected image. Make sure that the slide projector is square on to the canvas or paper to avoid any distortion of the image.

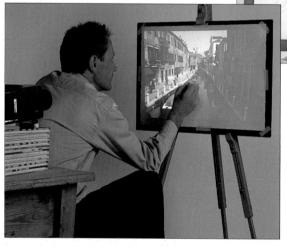

3 ▲ Here, the one-point perspective is relatively straightforward, yet there are many architectural details that are simply easier to draw by using a projector. Draw just enough detail to allow you to develop the painting in the way you want. Since you will be leaving your slide in the projector for some time as you draw, you will need to use a slide projector which incorporates an electric fan in order to keep it relatively cool.

Enlarging your image

If you use a slide projector with a lens of variable focal length, you can make the image bigger or smaller by rotating the lens rather than by moving the canvas forward or back, which can be rather awkward. Using a slide projector in this way, you can crop the image and establish the composition that suits your ideas for the painting. You can use any medium for capturing the essential components of an image. Here, the image is being drawn out monochromatically on a canvas using a synthetic brush and thick acrylic paint.

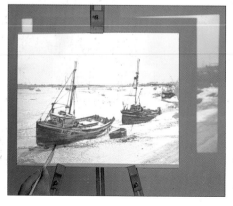

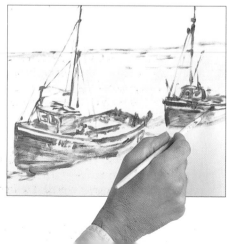

Computer-generated images

There is now a widely available selection of computer software that allows you to draw plans and elevations and put them into whatever kind of perspective projection you choose. You can look at the resulting three-dimensional image from any angle, from close-to or far away. This can be done without having to go through the laborious task of drawing everything with a pencil and set square.

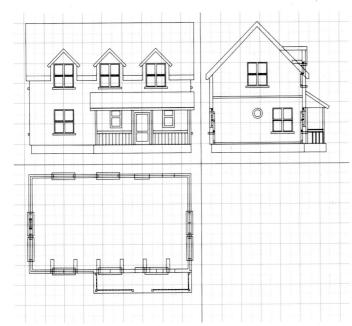

1 ▲ The computer can scan existing plans or create them from simple instructions. Here, the plan, and front and side elevations, which are drawn to scale, are all the computer needs to set up the perspective model.

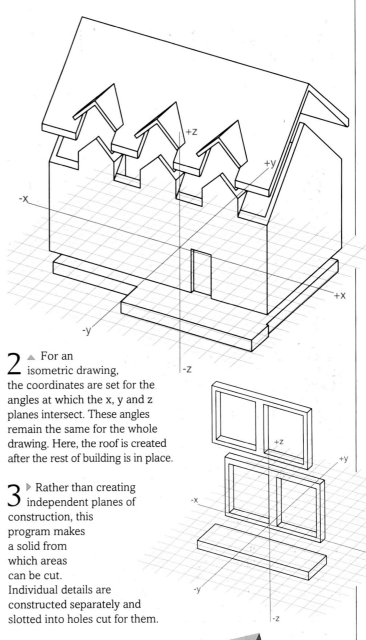

2 ▲ For an isometric drawing, the coordinates are set for the angles at which the x, y and z planes intersect. These angles remain the same for the whole drawing. Here, the roof is created after the rest of building is in place.

3 ▷ Rather than creating independent planes of construction, this program makes a solid from which areas can be cut. Individual details are constructed separately and slotted into holes cut for them.

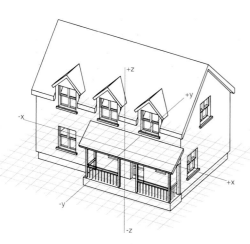

4 ▲ The completed isometric projection gives a clear image of the structure of the building in three dimensions. This projection is in perfect scale and can be used by the artist or architect to take measurements not given on the plan and elevations.

5 ▷ By pressing one command, the isometric building is rendered into linear perspective. The image can now be rotated and viewed from any angle, from close-to (with the attendant distortion) or from farther away.

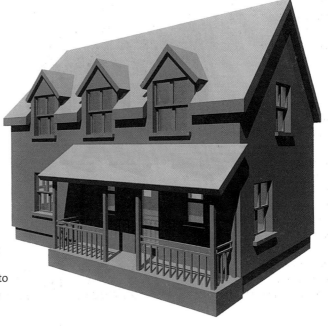

GALLERY OF PERSPECTIVE DEVICES

THERE IS A LONG TRADITION of artists using a wide range of mechanical or electronic devices as an aid to accurate representation, from a simple card viewfinder to complex computer-generated methods. The accuracy of architectural detail in Canaletto's work and recent research into that of Vermeer indicate the use of the camera obscura. Both David Hockney and Gerhard Richter are among the many contemporary artists to have used slide projectors and other projection equipment.

Johannes Vermeer, *Woman Writing a Letter and her Maid,* 1671, *72.2 x 59.5 cm (28½ x 23½ in)*
Vermeer may not have needed a camera obscura for the simple one-point construction that underlies this painting. But the perfect placing of the characters, the heightening of the luminous contrasts, the economy of the painting style, coupled with the versimilitude, all point to the use of such a device.

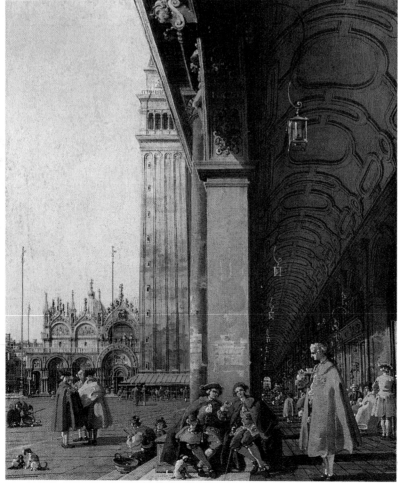

Antonio Canaletto, *Venice: Piazza San Marco and the Colonnade of the Procuratie Nuove,* c.1756, *46 x 38 cm (18 x 15 in)*
In this wide-angle view of the Piazza San Marco, the tiny impasto touches of light opaque colour showing the highlights are slightly over-exaggerated, as though seen through the lens of a camera obscura.

The lines of the wall and those of the window to the left converge to a vanishing point at the centre of vision where the woman's head is bowed as she writes the letter.

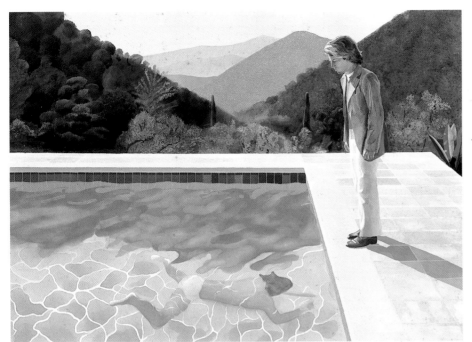

David Hockney, *Portrait of an Artist (Pool with Two Figures),* 1972,

2.13 m x 3.05 m (7 ft x 10 ft)
Hockney is a prolific photographer and has made a number of paintings where elements from different photographs are incorporated in a single unified composition. The subject here was suggested by two photographs lying on the floor of Hockney's studio in such a way that the standing figure seemed to be looking at the swimmer. The film A Bigger Splash *featured Hockney working on this painting and included a number of photographs of the swimmer to which the painter was able to refer. It showed how the photograph of the standing figure was projected onto the canvas so that Hockney could make an accurate sketch. The resulting painting has a remarkable clarity and freshness, with its contrast between the light and air of the hills and the clear blue water of the pool. The slope of the pool is unnerving, for the central vanishing point is in the sky at the top edge of the painting.*

The pool is painted in transparent acrylic washes to give a watery look. The pool surround is painted opaquely to emphasize its solidity.

The photograph of the underwater swimmer was taken in Hollywood in 1966. The reference has enabled Hockney to give an accurate image of the underwater distortion of the figure.

Gerhard Richter, *Meadow,* 1987,

82 x 122 cm (32 x 48 in)
Richter's landscape oil paintings are transcriptions of photographs. They are initially sketched in by projecting a slide onto the canvas. This allows the artist to stay close to the form of the original image. But in painting these images, Richter completely transforms them, painstakingly echoing the blurred edge of a form by the subtle blending of oil colour. Oil is, of course, the one painting medium that stays wet for long enough to manipulate in this way. These strange landscapes have a self-contained quality – a kind of heartlessness that is nonetheless compelling.

ANAMORPHOSIS

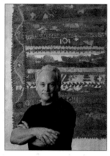

Photo reference
By working from a photograph and on a flat surface, you can trace up a grid more easily than by drawing from reality.

ANAMORPHIC PROJECTION is merely a reversal of Alberti's method of putting a grid into perspective (*see* p. 20). By using a simple grid sytstem, the artist is able to create a highly distorted image of an object, which, when seen from an oblique angle, reverts to its original appearance. Anamorphosis has been popular for centuries as a means of concealing certain kinds of imagery from the uninitiated, of putting hidden messages into paintings and drawings or simply to point out the very illusionistic nature of painting itself. Mastering the art of anamorphosis is a good introduction to the use of distortion, showing how perspective can be manipulated to achieve the painted image you require.

Other forms of perspective distortion
During the Renaissance, awareness of the illusionistic effects of perspective led to the use of alternative forms in architecture and painting, such as accelerated perspective. Instead of being built parallel to each other, rows of columns on either side of a corridor might actually be built to converge, making the corridor appear longer than it is. The effects of counter perspective were well known to the ancient Greeks. Lettering on the side of a building is carved to a larger scale higher up than that carved lower down, if both are to be seen from the ground at the same size.

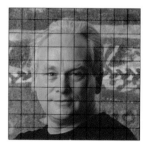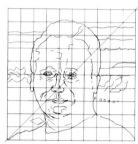

1 ▲ Construct a grid over your photograph and then transfer this image to a separate piece of paper, using the proportions of the squares to establish the proportions of the features. By drawing a diagonal through the grid, you can establish further centre points, which will enable you to copy more difficult features, such as the eyes.

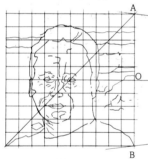

2 ▲ Once you have copied your image, extend the centre line of the grid (O) to four times that of the width of the grid itself. Then draw diagonals from the right hand corners of the grid (A and B) to join up with the farthest point of this centre line (X). You can play around with the proportions depending on how distorted you want the image to be. The longer the line OX, the greater the distortion will be; the greater the distortion, the closer to the picture plane the viewer must be.

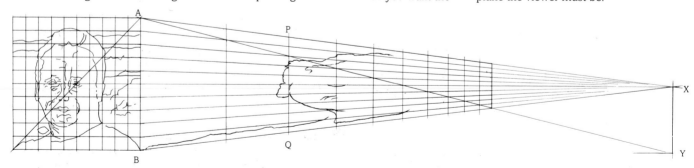

3 ▲ Join each of the grid points along the line AB to the point X. Plot a vertical line down through the point X measuring half the height of the grid (AB), then draw a line down from the top left-hand side of the grid (A) to the bottom of this new line (Y). The points at which the line AY cuts the horizontal lines will give you the points at which to plot your verticals (PQ, etc.). These divide the image according to the vertical lines of the grid but are spaced increasingly closer together as you move to the right.

4 ▷ Keep your gridded image on a separate piece of paper. You can then lay this over the area that you wish to distort. The grid can be drawn in coloured pencil to avoid confusion. Draw in the main outlines of the face first, such as the neck and chin and the sides of the face. This will give you a good framework within which to work.

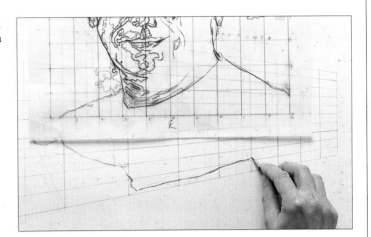

5 ▲ Divide the quadrilaterals of the distorted grid by drawing diagonals from corner to corner as you did earlier with the regular grid. When putting in the features, try to keep in mind the outline of the grid. You can erase these extra lines later on as you build up your image.

6 ▲ To draw in the heavier details, use a solid graphite pencil, this smudges easily and is thus useful when working up areas of tonal shading. Remember that the right-hand side of your image will need to be heavier in tone than that on the left and inevitably the features will be closer together, whilst the distortion will be greater in the left-hand side.

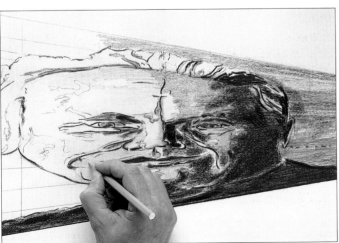

7 ▲ Start to fill in the skin tones with a light pink pencil. You can change the nature of the drawing's texture by altering the nature of your pencil strokes. In a loose portrait like this, different angled stripes and shapes, and even curved lines for shading, will give an interesting surface and create texture and depth.

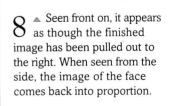

8 ▲ Seen front on, it appears as though the finished image has been pulled out to the right. When seen from the side, the image of the face comes back into proportion.

Side-angle view

The picture has been turned to the side to show the correct viewing angle of the picture. The tilted picture plane enables us to see the image of the face as in the original photographic reference.

Philip O'Reilly

CURVILINEAR PERSPECTIVE

LEONARDO DA VINCI'S observations leading to the idea of curvilinear perspective seem obvious when they are pointed out to us. We have all had the experience of standing under a long, high bridge and seen its two ends appear to curve down on each side, though we know the bridge is straight. But it is only relatively recently that artists seem to have rediscovered these ideas as forming the basis for a way of representing the world around us. The complex geometry of curvilinear perspective makes it more sensible for artists to use these ideas according to their actual experiences rather than to construct images along complex theoretical lines. In this respect, multiple sketches and photographs can be a great help.

Curved staircase
In this montage of black-and-white photographs, we are able to look up underneath the top steps of the spiral staircase as well as down on the bottom ones. The composition defies the verticality of the central post supporting the structure as it curves back into the space away from the viewer at the top, and to a lesser extent at the bottom.

Curvilinear perspective allows us to encompass much more of an image than would be possible using conventional linear perspective. In the latter case, you have to be a certain distance away from your subject to get everything in. We get a real sense of the whole structure in a way that seems to physically involve us in the space that is represented.

Straight picture plane
Leonardo drew three cylindrical columns of equal width, parallel with the picture plane (here, shown red). He demonstrated that, according to linear perspective, the two outer columns would appear wider than that in the centre. Since the viewer was farther away from the two outer columns, this was not how the viewer would see them.

Curved picture plane
In order for the outer two columns to look the same width, or smaller, the picture plane (here, shown red) would have to be curved. This ties in with Leonardo's observations of wide-angle views, in which he demonstrated that a long, rectangular, horizontal wall parallel with the picture plane would need to be drawn converging to the left and right, either towards a centre line or as a curved line.

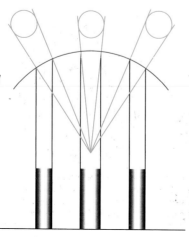

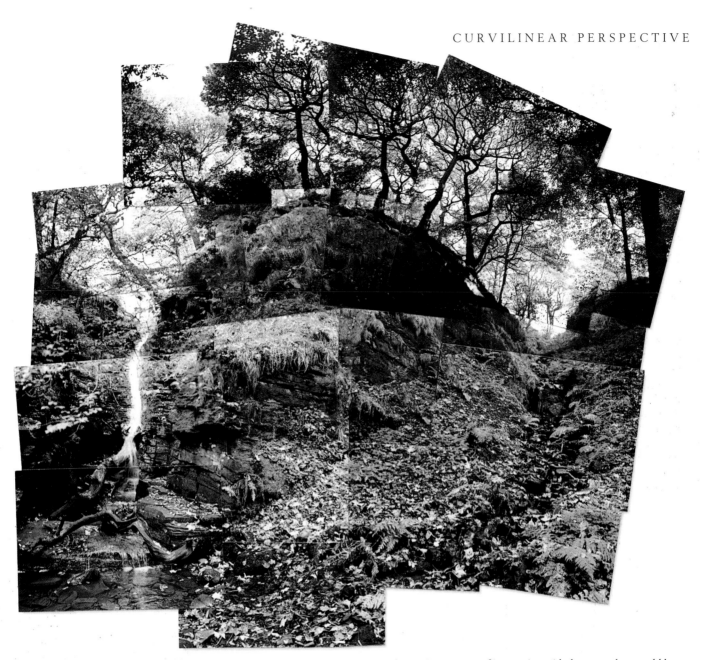

Woodland scene

This montage sweeps around the space both horizontally and vertically, creating a circle in the centre of the composition bounded by the curving line of the knoll against the sky, the waterfall on the left and the track to the right. The structure of the landscape may be exaggerated by this means, but it gives a sense of integration with the space that would be impossible using conventional perspective methods. Such an image is compelling in its own right, but could well form the visual source for a painting. A less obviously curved image would be achieved by moving the individual images farther apart.

CURVILINEAR SPHERES

An image published by Hermann von Helmholtz in his *Handbuch der Physiologischen Optik (1856-66)* showed a circular chequerboard of black and white squares in which the lines curved progressively outwards from the centre. When this was viewed from a particular distance, the curved lines appeared to be straight. This confirms the idea that according to natural perspective, when we look at a subject with straight edges from close-to, that is, with a wide angle of vision, its straight edges appear to curve. This is the basis of curvilinear perspective. The spheres right illustrate Helmholtz's idea.

If you look at this chequered sphere from very close-to with one eye, it looks like the sphere in the centre when seen from a normal distance.

This is how the image on the left looks when seen from close-to with one eye closed. Looked at from close-to you get the image on the right.

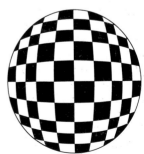

This is how the central image looks from close-to. The edges of the image are distorted – this is the effect that you get in curvilinear perspective.

GALLERY OF CURVILINEAR PERSPECTIVE

IN RECENT TIMES, artists have made paintings that attempt to go beyond the constraints of linear perspective in order to celebrate a wider angle of vision and the curving lines of the natural perspective we actually perceive in the world. The seeds of this new vision are evident in Edward Lear's watercolour, while the Carel Weight painting shows an understanding of how curvilinear perspective can be incorporated into a rectangular format. Other artists, such as David Hockney, show how we can dispense with the rectangle altogether in works which give an all-embracing sense of the subject.

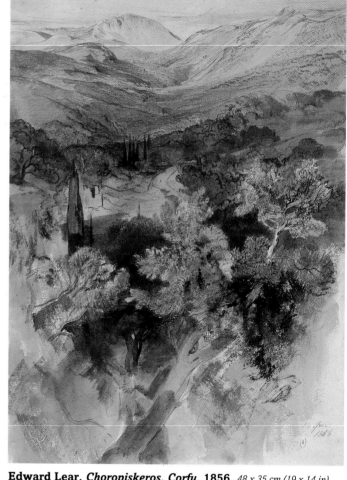

Edward Lear, *Choropiskeros, Corfu,* **1856,** *48 x 35 cm (19 x 14 in)*
Lear takes a multiple viewpoint that sweeps in a vertical line from the trunk of the tree in the foreground – where the artist is looking down – up through the middle distance to the distant hills and the high horizon at the top of the painting – where the artist is looking up. This gives a great sense of the breadth of the landscape, pushing against the confines of the rectangle.

David Hockney, *Sitting in the Zen Garden at the Rioanji Temple, Kyoto, Japan,* **1983,** *1.45 x 1.17 m (57 x 46 in)*
Hockney's photo-montages achieve their curvilinear effect by the artist minutely changing the plane of the camera with each shot that is taken.

This detail resembles a conventional perspective composition. When seen in relation to the whole, it is clear how much additional space is being depicted.

The **composition** radiates from the fountain like the spokes of a wheel.

Stanley Spencer, *Filling Water Bottles,* **1923-32**
Spencer compresses the imagery on the picture plane, pulling objects and figures into the painting from the edges of vision. The work here has a pattern-like quality that makes the viewer very conscious of surface. But at the same time, parts of the imagery are pushed forward, others back, at varying angles, resulting in a strong sense of densely-filled space. This panel comes from a series of images that decorate a chapel wall.

A small part of the image works as an intriguing, though more conventional, composition in its own right.

Carel Weight RA, *The Moment,* **1955,** *61 x 183 cm (24 x 72 in)*
The wide angle of view, with the curving of the wall and kerb, creates the broad panoramic space in which the drama of the painting is enacted. Such a construction gives the viewer a heightened sense of the moment referred to in the title. At such moments, we retain a clear snapshot of the whole scene and its very ordinariness becomes charged with meaning.

CURVILINEAR COMPOSITION

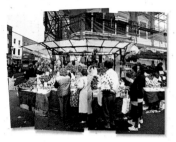

Fragmented reference
The photographic source for the painting is somewhat fragmented, but contains much clear and useful visual information from which the pastel work can be constructed.

THE OFTEN CRAMPED SPACE around a busy market stall would make it very difficult to establish a sufficiently distant station point necessary to make an accurate drawing of it using linear perspective. In fact, conventional perspective would not give as good a sense of the bustle, the characters, the colourful, heaped piles of fruit and vegetables and the feeling of integration within the locality that a curvilinear approach helps to provide. The artist has taken a preliminary series of photographs from a single standing position, moving the camera from left to right to create a miniature panorama that encompasses the whole scene. The pastel painting smooths out the disjunctions in the photographic reference and emphasizes the curvilinear sweep of the composition.

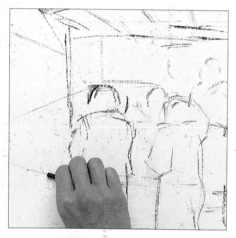

1 ◀ Establish the basic structure by drawing the two lines of the awning curving over the stall and the line of the front of the stall, curving up and round. Mark these in faintly in charcoal so that you can brush them off again if you wish. Begin to sketch in the broad shapes of the figures.

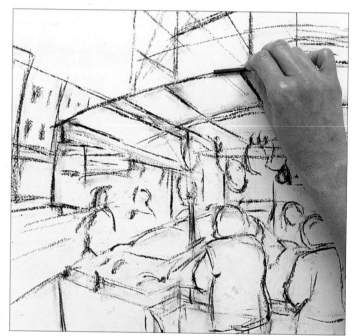

2 ▲ Once you are satisfied that your whole composition fits well on the paper, begin to firm up the structure of the figures and the stall. Do not use so much charcoal that you will sully the pastel.

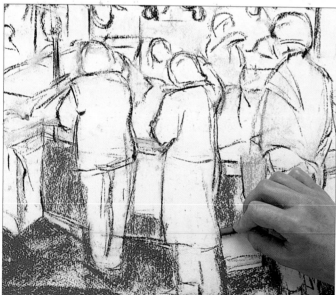

3 ▲ Use the broad side of a deep, cool green pastel to fill in darker areas of tone between the figures at the front of the stall and on the ground. Here, a mid-toned grey/blue retains a sense of colour and is a good base for the darker tones that will be applied later. The dark colours create areas of negative space.

4 ◀ Sketch in an indication of the colours for the hair and clothes of the figures. Lay a pale blue tone over the top of the awning.

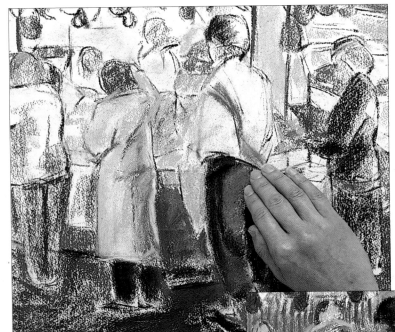

5 ▷ Build up the forms by adding colour. In each particular area, use adjacent colour harmonies in order to keep the colours looking clean. In an area predominantly orange or red, for example, use only reds, oranges and warm yellows. Avoid complementary blues in the shadows. For the woman's trousers in the foreground, use adjacent mid-toned blue/greys, deeper blues and purples. Rub colours with the fingers to blend.

6 ▲ When you have filled in the underlying colour, as in the sky, draw in the scaffolding using the broad sharp edge of the pastel.

7 ◁ Add the stripes to the awning. Keep the colour clean by making the lines directly in single, bold strokes.

8 ▷ At this final stage, add the very darkest tones and the highlights. This will give the painting more effective contrasts.

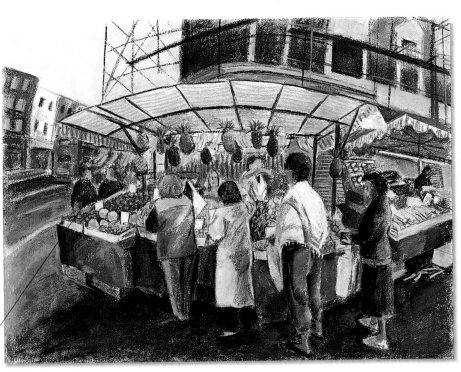

Market Scene, Hackney, London
In the finished work, the purity of the bright colours has been retained, but not at the expense of the tonal contrasts, which remain sharp. The curvilinear perspective gives the feeling not only that we are seeing something completely but also of participating in a shared experience.

The artist has wisely avoided giving any real definition to the faces of the figures.

Jane Gifford

Materials

Pastels

Charcoal

67

Gallery of Alternative Approaches

THE PLURALITY OF APPROACHES and styles in twentieth-century painting and other two-dimensional art forms has meant that artists no longer feel the need to rely on a particular form of conventional perspective. Artists may draw inspiration from any system or source that seems to offer the best way of solving a problem or expressing an idea. For many artists there is a great freedom in not being locked into a particular convention. It allows them to explore the techniques of other cultures and to invent new ones that may be more appropriate to new media. Here, each artist has adopted an approach that is appropriate to the context of the work, from the massive shifts in scale in the Gilbert and George work to the spatial compression of the painting by Mick Rooney.

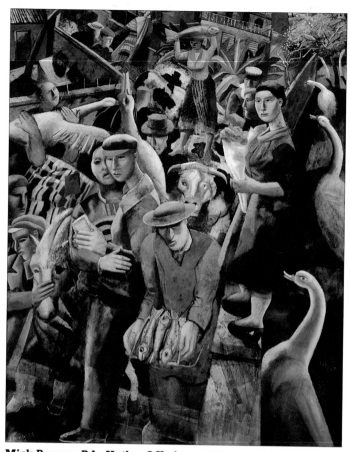

Mick Rooney RA, *Votive Offerings,* 1989, *1.24 x 1.02 m (49 x 40 in)*
This painting takes a high viewpoint, with the horizon line well above the top edge of the painting and the ground plane practically parallel with the picture plane at the bottom. It encompasses a very wide angle of view and compresses the perspective so that we look at the narrative as though through the zoom lens of a camera with little depth of field. The result is a rich menagerie of forms of many species, a busy, fecund work with an appropriate perspective framework for the scene it so vigorously portrays.

Umberto Boccioni, *The Laugh,* 1911,
1.1 x 1.45 m (43 x 57 in)
Along with his Futurist colleagues, Boccioni rejected what he saw as outmoded conventions of linear perspective. This work is a kaleidoscope of visual fragments, a mixture of diverse visual sensations, in movement, complexity and bright, saturated complementary colours.

Within the shifting planes of the painting, scenes of apparent realism are visible.

Gilbert and George, *City Drop*, 1991, *2.53 x 4.97 m (8 ft 4 in x 16 ft 3 in)*
Just as Gilbert and George have reworked or subverted a traditional religious theme of apotheosis or ascension, so they have created their own version of a standard perspective. The artists themselves are featured precariously balanced on giant hands as if on some nightmare big dipper. At each side, the houses, like flats on a stage set, descend steeply in perspective to a central vanishing point below the arm and the bottom edge of the work. This has the effect of underlining the void below the figures perched high above. Their vulnerability is emphasized by the high viewpoint, as if seen from the height of the figures themselves. The feeling of vast space is echoed in the ground plane behind the houses that stretches to the horizon. It is an entirely built-up landscape, with its row upon row of terraced housing. The areas of foreground, middle ground and distance are plainly delineated, each with its clear part to play in the drama.*

Anthony Green RA, *Paradise*, 1993, *diameter 2.62 m (8 ft 7 in)*
In this painting, the artist opens out the space, like the opening of the petals of a flower. The imagery shows an intimate domestic scene and we feel the painting could close up again on this personal encounter just as a flower at night. Green has come up against the limitations of conventional perspective and has used the shape of the canvas to suggest the opening out of two-dimensional space.

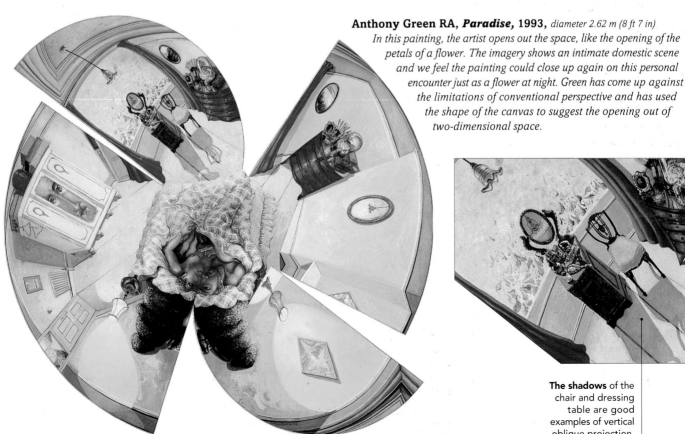

The shadows of the chair and dressing table are good examples of vertical oblique projection.

69

GLOSSARY

ACCELERATED PERSPECTIVE Sometimes used in stage and film sets and occasionally in architecture. It exaggerates the effects of perspective, so that a shallow stage, for example, can be made to look deeper.

ANAMORPHOSIS The distortion of an image by transferring it from a regular rectangular grid to a stretched perspective grid, so that when seen from an oblique angle, it reverts to its original appearance.

ASCENDING VANISHING POINT A point above the horizon line to which two or more parallel lines in the same plane and receding away from the viewer appear to converge. For example, in a sloping roof.

ATMOSPHERIC (OR AERIAL) PERSPECTIVE The effect of the atmosphere on the way we perceive tones and colours as they recede towards the horizon. Tones lighten and colours become cooler or more blue.

AXONOMETRIC PROJECTION A system where a plan is set up at a fixed angle to the horizontal, such as 45 degrees, and verticals are drawn true to scale to show the sides of the object.

CAMERA LUCIDA A drawing instrument based on a prism, it allows artists to see and trace the outline of the subject of their drawing directed onto the paper.

CAMERA OBSCURA An instrument for projecting an image from life onto a wall or canvas. It incorporates a focusing lens and a mirror for turning the image upright. The interior of the camera obscura has to be kept dark so that the projected image can be seen.

CENTRE LINE OF VISION (LINE OF SIGHT) An imaginary line from the artist's eye to the horizon, bisecting the angle of the cone of vision and at 90 degrees to the picture plane. It intersects the horizon line on the picture plane at the centre of vision.

CENTRE OF VISION The point on the horizon line at the intersection with the centre line of vision. It is the point we are directly looking at and the single vanishing point in one-point perspective.

CONE OF VISION A cone of up to 60 degrees, within which a subject can be comfortably represented without perceived distortion.

CONVERGENCE The apparent coming together of parallel lines receding from the viewer towards a fixed point.

COUNTER PERSPECTIVE In counter perspective, if lettering or relief at different levels on a building is to appear the same size when seen from the ground, it must be carved or painted at a larger scale higher up than lower down.

CURVILINEAR PERSPECTIVE A perspective system in which lines that may in reality be straight appear curved. It applies particularly when an image is seen from close-to or with a wide angle of vision.

DESCENDING VANISHING POINT A point below the horizon line to which two or more parallel lines in the same plane and receding away from the viewer appear to converge – as in a sloping street.

DIAGONAL VANISHING POINT The vanishing point for lines receding at 45 degrees from the picture plane.

DISTANCE POINT A point on the horizon line from which a line is drawn to establish the intersection points of transversals with orthogonals. In one-point perspective, it corresponds to a diagonal vanishing point.

ELEVATION A two-dimensional scale drawing of the side of a building.

ELLIPSE A regular oval shape formed when a circle is put into perspective.

EYE-LEVEL The distance from the ground line to the eye of the viewer establishes the eye-level. It is the same line as the horizon line.

FINDER A cardboard viewer in which the shape of the paper or canvas is cut out to scale. This is held up at arm's length by the artist who views the scene through it in order to establish what will be drawn or painted and roughly where it will be on the canvas.

FORESHORTENING If you are looking across a courtyard of square pavement slabs in which two parallel sides of the slabs recede directly away from you in a straight line towards a central vanishing point and the others recede horizontally, the distance between the lateral or horizontal edges will get progressively smaller. This is foreshortening. The degree of foreshortening depends on the angle at which you view an object.

GRID SYSTEM A method of putting objects into perspective in relation to a drawn perspective grid of rectangles.

Two-point painting

Three-point painting

Atmospheric perspective

GROUND LINE The bottom edge of the picture plane where it cuts the ground plane. It is parallel to the horizon line.

GROUND PLANE The level ground upon which the artist is imagined to be standing in order to view a scene and which stretches to the horizon. The ground plane is in reality uneven and we are able to take account of its ascending and descending planes and uneven contours when making perspective drawings.

HEIGHT LINE (MEASURE LINE) A vertical line on the picture plane with heights marked to scale of objects that may be behind or in front of the picture plane.

HORIZON LINE The line where the sea and the sky appear to meet. The horizon line is always at your eye-level and is the location of horizontal vanishing points.

ISOMETRIC PROJECTION A form of axonometric projection that denies the apparent convergence of receding lines. Height lines are true and to scale. The angle of receding lines relates to the angles at which the planes of the cube meet.

LINEAR (ARTIFICIAL) PERSPECTIVE A system of representing space on a two-dimensional surface by recording the intersection on the picture plane of rays of light from an object as they converge on the eye of the viewer.

MEASURING POINT A point for each vanishing point on the horizon line obtained by describing an arc, with the vanishing point as centre, from the station point to intersect the picture plane on the horizon line. A measuring point provides a simple means of locating the position of objects behind or in front of the picture plane by reference to scale measurements on the picture plane.

OBLIQUE PROJECTION In oblique projection, an elevation is drawn and receding lines are added all at the same angle, for example 45 degrees to the horizontal. The length of these receding lines is reduced by the same ratio of the 90-degree angle to the angle of the elevation that the receding line represents (i.e., if it is 45 degrees, it is half as long).

ONE-POINT PERSPECTIVE The simplest linear perspective construction where all parallel lines at right angles to the picture plane and parallel with the ground plane appear to converge at the same vanishing point on the horizon.

ORTHOGONALS Lines that recede at right angles from the picture plane to a vanishing point on the horizon.

ORTHOGRAPHIC PROJECTION The standard method of showing a plan and elevation.

PICTURE PLANE The imaginary plane on which we make an image of the scene we see through it, representing the point of intersection of rays of light from objects in the scene to the artist's eye. It is normally set at 90 degrees to the ground plane, but it can be tilted if we are looking up or down.

PLAN A two-dimensional scale drawing of a horizontal section of an object, such as a building.

PROJECTION In linear perspective, carrying lines from the station point to points on the plan and thereafter to the picture plane where the points of intersection are marked.

SECTION A scale drawing showing a two-dimensional slice through an object, such as a building, in the vertical or horizontal plane.

STATION POINT The position on the ground plane from which the artist views the subject.

SUBDIVISION A method of putting images into perspective by subdividing within shapes such as simple rectangles, the outlines of which have been put into perspective.

THREE-POINT PERSPECTIVE Perspective in which the object is at an angle vertically to the picture plane in addition to the horizontal plane. An additional vanishing point for the third (vertical) plane will be required.

TRANSVERSALS Receding horizontal lines parallel to the picture plane.

TWO-POINT PERSPECTIVE A perspective construction where the object has its vertical edges parallel with the picture plane, but with its sides set at any angle to it. There will be two vanishing points, both on the horizon line.

VANISHING AXIS A vertical axis at right angles to the horizon line. Descending or ascending parallel lines in the same plane will have their vanishing points on this axis.

VANISHING LINE A line that converges on a vanishing point.

VANISHING POINT The point at which any two or more parallel lines in the same plane and receding from the viewer appear to converge.

VIEWPOINT The point, particularly the height, from which the artist sees the scene. It will determine the height of the horizon line and the nature of the composition.

A NOTE ON MEASURING

When you are sketching and want to establish the angle of the side of a building, you can hold two rulers up to the scene and transfer the angle onto your page – the technique described on p. 15. But moving across from a scene to your drawing can make it difficult to keep the rulers at the correct angle and you may inadvertently move them. So it is easier and more accurate to use a small pair of dividers or a couple of strips of straight card hinged at one end. Hold this at arm's length, keeping one strip of card or half of the dividers horizontal and adjust the other half until it lines up with the angle of the building. It is easy to line up the horizontal half with the top or bottom edge of your sketchpad and draw the angle perfectly. This method is particularly useful when learning to draw before you have learnt to judge by eye.

Anamorphosis

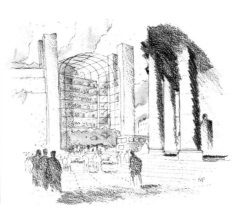

Architectural sketch

*I*NDEX

A
Aboriginal art, 8
accelerated perspective, 60
acrylic washes, 43, 49
aerial perspective, 24-9
aerial views, 40
Alberti, Leon Battista, 10, 20, 60
anamorphosis, 60-1
angle of incidence, 48, 49
architecture:
 gallery, 46-7
 one-point perspective, 21
 plans and elevations, 38-9
 three-point perspective, 19, 40-5
 two-point perspective, 18, 31
artificial light, 52-3
ascending vanishing point, 36
atmospheric perspective, 24-9
axonometric projection, 9

B
bird's-eye view, 40
Boccioni, Umberto, 68
Bowyer, RA, William, 55
box grid construction, 34-5
Brunelleschi, Filippo, 10
Byzantine art, 9

C
camera lucida, 56
camera obscura, 56, 58
cameras, lenses, 56
Canaletto, Antonio, 58
Carline, Sydney, 46
centre of vision, 16
centre line of vision, 16
children's drawings, 7
circles, 22-3
clouds, 27

colour, 24-5
computer-generated images, 57
cone of vision, 11, 12-13, 17
convergence, 20
counter perspective, 60
cubism, 11
curves, 22-3
curvilinear perspective, 11, 62-7

D
Degas, Edgar, 54
detail, 26-7
devices, 56-9
diagonal vanishing point, 20-1
Dibbets, Jan, 11
distortion, 16-17, 60
drawing frames, 56
Dürer, Albrecht, 11

E
Egypt, ancient, 6, 9
elevations:
 computer-generated images, 57
 two-point perspective, 18-9, 30-1, 38-9
ellipses, 22-3
enlargement, 31, 56
eye-level, 16-17, 31

F
finders, 56
foreshortening, 9, 11
 one-point perspective, 20
 two-point perspective, 19
Foster, Norman, 7
Fouquet, Jean, 11
frames, 56
Friedrich, Caspar David, 29
futurism, 11, 68

G
Gilbert and George, 68, 69
glasses:
 reducing, 56
 sketching, 14-15
Greece, ancient, 9, 60
Green, RA, Anthony, 11, 69
grid system, 10
 anamorphosis, 60-1
 drawing frames, 56
 one-point perspective, 20-21, 34-5
 two-point perspective, 30
ground plane, 16

H
Helmholtz, Hermann von, 63
Hockney, David, 11, 58-9, 64
horizon line, 16-17
 box grid construction, 34-5
 inclined planes, 36-7

I
illusionism, 11, 60
inclined planes, 23, 36-7
isometric projection, 9, 57

J
Jacklin, RA, Bill, 29

L
landscapes:
 atmospheric perspective, 24-9
 gallery, 46-7
 three-point perspective, 40-1
Lear, Edward, 64
Léger, Fernand, 11

Leonardo da Vinci, 11, 62
Levene, RA, Ben, 55
light:
 angle of incidence, 48, 49
 artificial, 52-3
 sunlight, 50-1
line drawings, 26
linear perspective, 6-7

M
Malangi, David, 8
Martin, John, 11
measuring, 15
measuring point, 20-1, 30
Monet, Claude, 55
montages, 62-3, 64
Mughal paintings, 9

O
oblique projection, 9
one-point perspective, 6, 18
 box grid construction, 34-5
 principles, 20-1
orthogonals, 20
orthographic projection, 9

P
parallel lines, 18-20
pastels, 52-3
pavements, 20
pencils, 15
photographs, 11, 56, 60, 66
picture plane, 14-15, 16
 curvilinear perspective, 62
 projecting plans, 36
 three-point perspective, 40
 two-point perspective, 30-1
Piero della Francesca, 7, 10
plan:

computer-generated images, 57
two-point perspective, 30, 38-9
Poussin, Nicolas, 28
projection:
 axonometric, 9
 isometric, 9, 57
 orthographic, 9
 plans and elevations, 36
 three-point perspective, 40
 two-point perspective, 30-1

R
realism, 11
receding colours, 24-5
recession, 9
reducing glasses, 56
reflections, 48-9, 54-5
Renaissance, 11, 60
Richter, Gerhard, 58, 59
ripples, 49
Roman art, 9
Room of the Masks, 11
Rooney, RA, Mick, 68
Ruisdael, Jacob van, 28
rulers, 15

S
shadows, 50-1, 52, 54-5
sketching glass, 14-15
slide projectors, 56
Spencer, Stanley, 65
spheres, curvilinear, 63
station point, 16
sunlight, 50-1

T
three-point perspective, 19, 40-5
Tiepolo, Gian Battista, 11
tone, 24-5, 26
Tosa-Sumiyoshi School, 9
transversals, 20

Turner, J. M. W., 6, 11
two-point perspective, 18-19, 30-1, 32-3
 box grid construction, 35
 plans and elevations, 38-9

U
Uccello, Paolo, 10

V
Van Gogh, Vincent, 11
vanishing point:
 box grid construction, 34-5
 diagonal, 20-1
 horizon line, 17
 inclined planes, 36-7
 non-linear perspective, 9
 one-point perspective, 6, 18, 20-1
 shadows, 50, 52
 sunlight, 50
 three-point perspective, 19, 40-1, 42
 two-point perspective, 18-19, 30
Vasari, Giorgio, 10
Velázquez, Diego, 11
Vermeer, Johannes, 58
viewpoint, 16-7
 bird's-eye view, 40
 ellipses, 23
 high, 16, 31, 39
 horizon line, 16
 linear perspective, 6
 low, 17, 31, 39
 worm's-eye view, 40
Vitruvius, 9

W
watercolour, 27
Weight, RA, Carel, 64, 65
wide-angle views, 13
Witte, Emanuel de, 10

*A*CKNOWLEDGEMENTS

Author's acknowledgements
Ray Smith would like to thank Sean Moore and the managing team on the DK Art School series. Thanks also to Peter Jones, my editor, who showed a genuine talent for enhancing the clarity of the text while managing to make it fit, and to Spencer Holbrook, my designer, who managed to sustain a fresh, clear look to the work under the pressure of tough deadlines. Thank you to the many artists and illustrators whose paintings, drawings and photo-works illuminate the various aspects of perspective and to the DK photographers who continue to do a great professional job in the most amiable way. Special thanks to Guy Marsden for making a large number of excellent drawings during the early stages of the book.

Picture credits
Key: *t*=top, *b*=bottom, *c*=centre, *l*=left, *r*=right, *a/w*=artworks, RAAL= Royal Academy of Arts Library
Endpapers: Julian Bray; *p6: tr* The Trustees of the British Museum, London; *b* Turner, Tate Gallery, London; *p7: t* Ben Johnson; *c* Camilla Smith; *b* Norman Foster Associates; *p8: t* David Malangi, Founding Donor Fund 1984, (Ex Karel Kupka Collection), Collection: National Gallery of Australia, Canberra; *b* The Trustees of the British Museum, London; *p 9: t* Miniature from the Akbarnarma, By courtesy of the Trustees of the Victoria and Albert Museum, London; *b* Entertainments in Kyoto, By permission of the British Library; *p10: t* Uccello, Chiesa di Santa Maria Novella, Florence/ Bridgeman Art Library; *b* De Witte, Museum Boymans-van Beuningen/ Visual Arts Library; *p11: t* Tiepolo, Chiesa dei Gesuati, Venice/ Scala; *c* Dibbets, Castello di Rivoli, Museo d'Arte Contemporanea/ Photo Paolo Pellion di Persano/Ikona/ © ARS, NY and DACS, London 1995; *b* Léger, Solomon R. Guggenheim Museum, New York/ Photo AKG London/ © DACS 1995; *p12: tl* Martin Roche; *br* Sue Sareen; *p13:* all Ray Smith; *pp14-15:* all Ray Smith except sketches *p.15 b* Sue Sareen; *p16: tl* Martin Roche; *bl, br* Ray Smith; *p17: t:* Martin Roche; *bl, br* Ray Smith; *pp18-19:* diagrams Martin Roche; *p19 clb* Image Bank; *pp20-21:* diagrams Martin Roche; *p22: tl, br* Ray Smith/ Mark Annison; *bl, br* Julian Bray; *p23: tl* Julian Bray; *b* Ray Smith; *p24:* all Ray Smith; *p25: tr* Ray Smith; rest Julian Gregg; *p26: b* Ray Smith; *p27: t* Julian Gregg; *br* Ray Smith; *p28: t* Poussin, The Earl of Plymouth, National Museum of Wales; *b* Van Ruisdael, Kimbell Art Museum, Fort Worth, Texas; *p29: t* Friedrich, Hermitage, St. Petersburg/ Bridgeman Art Library; *b* Bill Jacklin, RA, RAAL; *pp30-31:* Ray Smith/Dinwiddie McClaren; *pp34-35:* Ray Smith/Dinwiddie McClaren; *p37:* Noel McCready; *pp38-39:* Guy Marsden; *p40:* Dinwiddie McClaren; *p41:* Julian Bray; *p46: tr* Michael Smith; *bl* Sydney Carline, Imperial War Museum, London; *p47: t* Ben Johnson; *b* David Prentice; *p48:* all Ray Smith; *p49: tr* Ray Smith/ Martin Roche; rest Jane Gifford; *pp50-51:* diagrams Guy Marsden; *a/w* Sue Sareen; *p54: tr* Degas, Musée D'Orsay, Paris; *bl* Ian Cook; *pp54-55: c* Ben Levene RA, RAAL; *p55: tr* William Bowyer RA, RAAL; *b* Monet, Orangerie, Paris; *p56:* all Ray Smith; *p57:* Guy Marsden/ Henry Newton Dunn; *p58 tr* Vermeer, Bridgeman Art Library/ Giraudon; *bl* Canaletto, Reproduced by courtesy of the Trustees, The National Gallery, London, *p59: t* © David Hockney; *br* Richter, Courtesy: Anthony d'Offay Gallery, London; *p62: l* Ray Smith/ Mark Annison; *r* S.J. Cappleman; *p63: t* Tabitha Sims; *b* Ray Smith/ Mark Annison after Helmholtz/ Lawrence Wright; *p64: tr* Lear, The Trustees of the British Museum, London; *bl* © David Hockney; *p65: t* Spencer, National Trust Photographic Library/ Roy Fox/ © Estate of Stanley Spencer 1995/ All right reserved DACS; *b* Carel Weight RA, City of Nottingham Museums; Castle Museum and Art Gallery; *p68: tr* Mick Rooney RA, RAAL; *bl* Boccioni, Museum of Modern Art, New York/ Photo AKG, London; *p69: t* Gilbert and George, Courtesy: Anthony d'Offay Gallery, London; *b* Anthony Green RA, RAAL

Additional photography:
Julian Bray: *p42;* Jane Gifford: *p49; p66;* Susanna Price: *p55; b;* Tim Ridley: *p12; p26 c; p48; p52;* Philippe Sebert: *p54: tr;* Ray Smith: *p15, p16; pp18-19:* all except *p19: clb; pp24-25; p26: tl; p27; p56 cl*

Additional editorial assistance: Ann Kay